BRIDGWATER
& THE RIVER PARRETT

ROD FITZHUGH

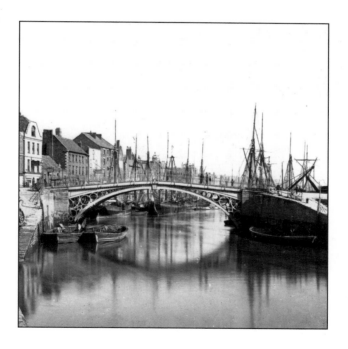

The
History
Press

First published by Alan Sutton Publishing, 1993
This new revised edition published in 2011 by

The History Press
The Mill, Brimscombe Port
Stroud, Gloucestershire, GL5 2QG
www.thehistorypress.co.uk

British Library Cataloguing in Publication Data.
A catalogue record for this book is available from the British
Library.

ISBN 978 0 7524 5293 7

Typesetting and origination by The History Press
Printed in Great Britain

Manufacturing managed by Jellyfish Print Solutions Ltd

CONTENTS

Introduction		5
1.	The Estuary	9
2.	Burnham-on-Sea	17
3.	Highbridge	29
4.	Combwich	41
5.	Dunball	51
6.	River Scene	61
7.	Bridgwater	79
8.	The Upper Reaches	145
9.	Langport	155
	Bibliography	159
	Author's Note	160

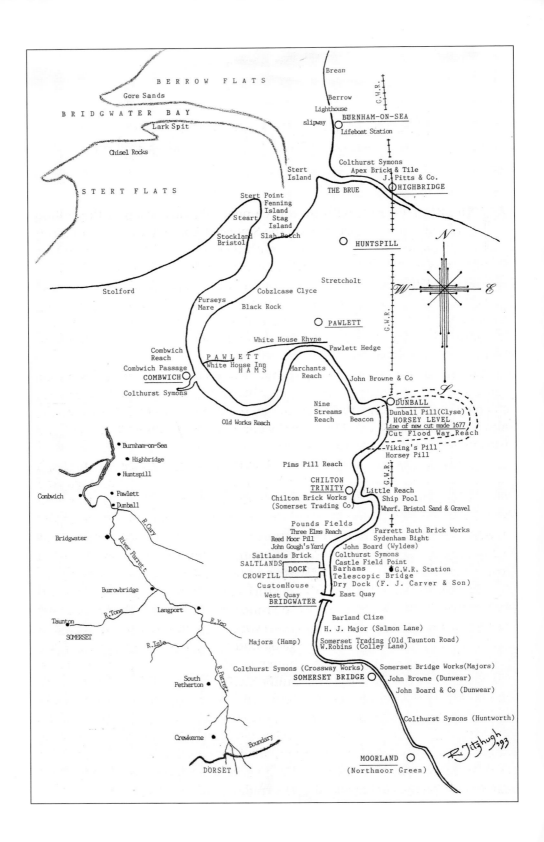

INTRODUCTION

The River Parrett, with its source near Winyards Gap in the rolling hills of north Dorset, crosses the Somerset boundary at South Perrott and passes close to Merriott, South Petherton and Muchelney, where it joins the River Isle. Just south of Langport the River Yeo flows in from the south-east. The River Tone has its confluence just south of Burrowbridge and the Parrett continues on into Bridgwater and then, in surprising winding fashion, to Dunball, Combwich, and Burnham-on-Sea, before emerging into the Severn Estuary in Bridgwater Bay, a total distance from source to sea of between 35 and 40 miles.

The combination of a winding course with its bore and neap tides means that, as a waterway, the Parrett has always been a potential hazard for shipping, navigable only to Bridgwater by the larger 400- to 500-ton vessels, and as far as Langport and Ilchester by barge, using the rivers Tone, Yeo and Isle and the Langport to Westport canal.

There is evidence of the use of the Parrett from the Bronze Age through to the time of the Phoenicians, Romans, Saxons, Vikings and Normans, and there were crossing points at Combwich, Crowpill and Bridgwater. However, it was not until the year 1200 and the grant of charters to Bridgwater, the building of the castle and the first stone bridge, that the town developed as a trading port. By 1300 merchant shipping brought into Bridgwater wine from France and exported corn, peas and beans to Ireland, France and Spain. By the fifteenth century the port was thriving with wine imports and cloth exports from Somerset and Dorset to France and Spain. The Bristol Channel ports became accustomed to ships carrying cargo to and from Bridgwater, and the wharves in the nearby towns and villages were hives of activity transferring goods to or from smaller craft and barges or horse-drawn carts together providing the distribution network. By 1500 Bridgwater was the largest port in Somerset, its merchants selling agricultural produce to Ireland and hides to Spain, and using the ships for increased trade with the other Bristol Channel ports. Coal, timber, iron and millstones were imported, and although the cloth trade diminished throughout the sixteenth and seventeenth centuries, trade actually improved, salt becoming an important cargo and Portugal being added to the trading nations.

The Bridgwater dry dock, built in 1743 for the repair, maintenance and building of ships, was a further incentive to ship owners to use the port. Over forty ships were built in the various shipyards along the river banks, creeks and pills during the eighteenth century, and the establishment of new industries producing bricks created a further increase in river and dock traffic.

The nineteenth century saw the Parrett at its peak, Bridgwater by then the leading industrial town in Somerset, with firms like Watsons, Luer and Company, David Williams, William Lowther, John Gough and F.J. Carver launching some 140 ships from their respective yards. Ships tied up at the wharves along the river, in town, village or countryside, as it was not until 1841 that the Bridgwater docks were opened. The excavated soil was piled on the north side, and in time became known as 'the mump', a small part of which remains.

The Bridgwater and Taunton Canal was extended to run into the western end of the docks, and the river and canal became linked. Local firms like Sully's, Axfords and Havilands as well as Stuckey and Bagehot of Langport became prominent ship owners, and by 1880 it was recorded that a quarter

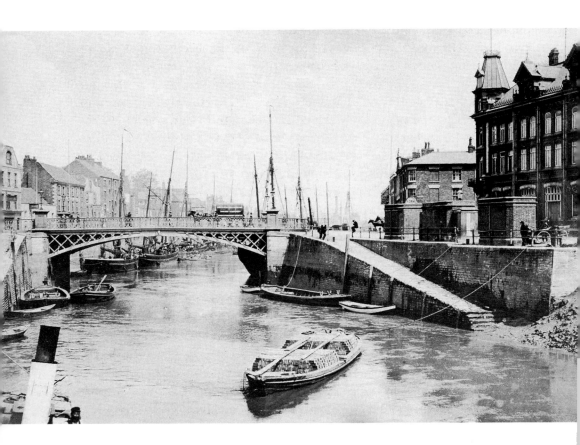

of a million tons of goods had been brought in during the previous twelve months. From sixteen brick and tile yards over twenty-four million bricks were exported downriver during the 1890s.

After so many centuries it was perhaps surprising that within twenty years the shipping trade declined so drastically. The opening of the Severn Tunnel in 1886 led to the railways being extended into Somerset and Dorset and then throughout the West Country. The waterways could not compete for goods traffic with the speed and penetration of the rail network, and there were financial losses in the docks. River wharves, starved of trade, started to close. Competition from the railways was coupled with the decline in the brick industry, which failed to mechanise and found the traditional 'Bath brick' outsold by new detergents and cleaning agents. Petroleum took over from coal, and bigger ships were berthing in larger and more accessible ports, so it was inevitable that shipping on the Parrett was nearing its end. Bridgwater docks finally closed on 31 July 1971, having only kept open so long for the sake of small trading craft. With the exception of trade at Dunball and Combwich, the River Parrett was reverting to pre-Bronze Age years. The wooden pillars against which the schooners, barques and other tall-masted ships had once tied up were slowly sinking in the mud, their remains and the occasional ribs of a hulk, a skeletal reminder of days gone by, the windowless ruin of Ware's warehouse the sightless skull of the cadaver of a once-active river. The weeds and ruins were signs of dereliction and defeat.

But, is the phoenix now rising again? The Bridgwater docks, cleared of decades of rubbish, have been developed as a marina and after some years, and the reopening into the docks of the restored Bridgwater and Taunton Canal in June 1994, now attract narrowboats and small craft to its moorings. Ware's warehouse was restored and converted into apartments and that side of the docks, as well as on the north and west sides, duly developed with further apartment blocks of an innovative architectural design. Employment in Bridgwater rises and falls as one industry, be it service or manufacturing, closes and another starts. Courtaulds/British Cellophane closed, but the Bristol Road from Bridgwater to Dunball is being developed by companies of national repute with warehouses, a hotel, and conference facilities. With the landscaping of the river bank, the Parrett is now an attractive backcloth for the resurgence of Bridgwater as a convenient business location, as close as it is to the M5 motorway. The Blake Museum displays all aspects of the heritage and history of Bridgwater and the river, and a museum to the brickyard industry next to the restored last brick kiln and museum, are welcome additions to the memories of the past. The exciting and imaginative prospect of a barrage across the river posed too many problems. It could have created an inland waterway to rival the Norfolk Broads, but there is

now no exit from the docks to the river, and a new fixed bridge spanning the River Parrett upstream from the docks precludes passage, other than for non-masted small boats. The Bridgwater and Taunton Canal is too short for it to be anything other than a weekend jaunt for pleasure boats, so the opportunity to regenerate the use of the waterways of Bridgwater, on the basis of current plans, seemingly has been lost.

From the Dorset border to Bridgwater Bay, the River Parrett, while a natural wildlife habitat, appeared destined to serve only as a drainage resource, and for the benefit of pleasure craft, the elver fishermen and ramblers. However, recently announced plans by EDF Energy for a third nuclear power station at Hinkley Point may well herald the increased use of Combwich as a port and the Parrett again may see laden vessels using its waters.

Rod Fitzhugh, May 2011

ONE

THE ESTUARY

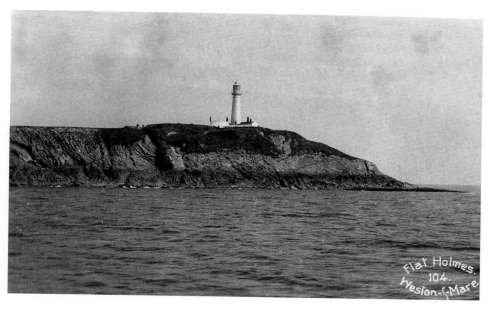

Flat Holm lighthouse, *c.* 1917. During the hours of darkness, or in fog and gales, Flat Holm lighthouse was a welcome sight on the Bristol Channel coastline. By its light, mariners could navigate their vessels clear of the dangerous reefs, sandbanks and rocks.

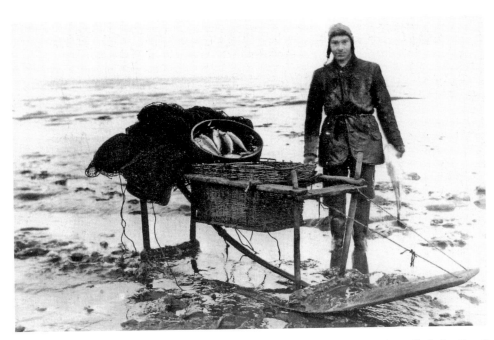

Stolford 'mud-horse', *c.* 1910. As the tide recedes in Bridgwater Bay the Sellick family of Stolford take their 'mud-horse' onto the Stert flats for the 2-mile journey to their fishing nets strung between elm stakes. The 'mud-horse', made from a rectangular elm frame on a ski-shaped base, carried a large wicker basket and was propelled by leaning over the back of the frame and pushing hard against the deep grey mud. Having collected the bass, skate, shrimps, eels, sprats, sole and other fish from the nets, it was imperative that the return journey was started as soon as the tide turned, as in minutes the nets were covered by sometimes 20ft of sea. The family continues the fishing tradition to this day.

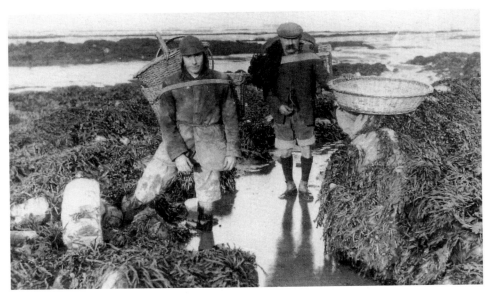

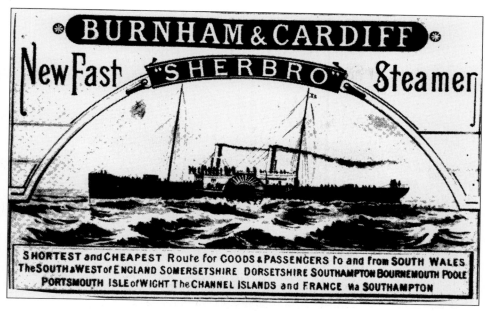

The twin-funnelled wooden paddle-steamer *Sherbro*, built in 1870 by John White of Cowes, was used between May 1884 and 1886 on the Burnham-on-Sea to Cardiff ferry route, and then on cruises from Cardiff to Weston-super-Mare, Watchet, Lynmouth and Ilfracombe until 1888. Some years after, Burnham-on-Sea jetty, situated alongside the slipway, ceased to be used by excursion vessels because of the build-up of silt and the dilapidated and dangerous pier timbers.

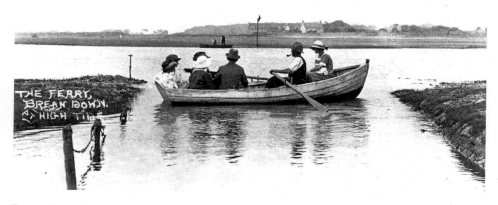

Brean Down ferry, one boat bringing ashore six passengers and the other on the far side awaiting others. The crossing of the River Axe from Brean Down to Uphill by these small ferry boats saved a journey of several miles inland via Lympsham.

Brean Down, looking towards Uphill.

Brean Down from the south, showing a thatched cottage and stables, with two little girls posing for the cameraman. Brean Down is now managed by the National Trust as a bird sanctuary and is well known for its natural history, archaeological remains and as a scene of outstanding natural beauty. It was from Brean Down in May 1897 that Marconi and George Kemp transmitted and received the first wireless messages across water.

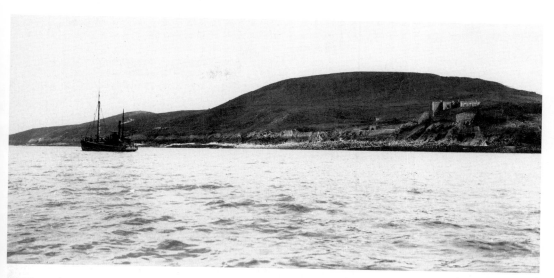

The fear of invasion by France prompted the utilisation of 4 acres of land for the building of Brean Down Fort in 1862, one of four such forts across the Bristol Channel developed with adjoining barracks and buildings and armed with cannon and guns, gunpowder and shot. Between 1905 and 1939 the fort was the more peaceful site of a café, but during the Second World War returned to wartime mode, being re-armed with guns and searchlights. Brean Down, 320ft high, has always been a landmark for shipping using the ports of the Bristol Channel and an ideal vantage point for tourists, as well as the military, for watching the comings and goings of vessels.

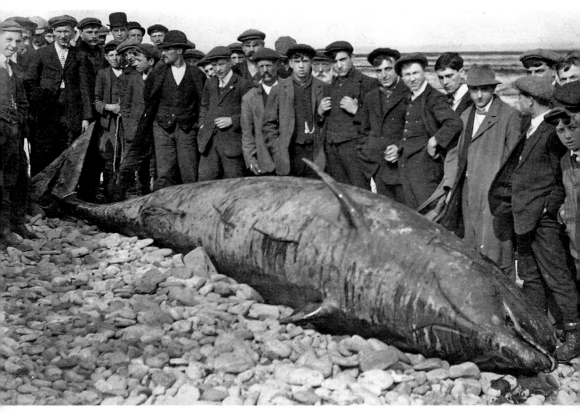

Stolford, 1912. While the River Parrett was well known for its salmon fishing, other large 'fish' have been landed from or stranded by its waters. In 1884 and 1888 'Royal' sturgeon were caught weighing in at 2½cwt, and later exhibited at Pople & Porters' fish and poultry shop in High Street, Bridgwater. In 1880, 1885 and 1913 porpoise totalling over a hundredweight were taken from the Parrett, a school also being sighted off Burnham-on-Sea in 1888. A large whale washed ashore at Combwich in the 1860s, and the bottle-nosed whale shown in this photograph beached itself on 27 September 1912 having been seen lashing around in the mud before the tide receded. Measured at some 19ft in length and weighing between 3 and 4 tons, it was buried in the vicinity, but not before hundreds of people had flocked to see such a rare event.

Opposite: Trows, *Sarah* and *Eliza*, *c*. 1936. Many of the River Severn trows ended their days minus masts and rigging and were then used as cargo-carrying barges or lighters. *Eliza*, built in 1865 at Runcorn, was registered at Bridgwater in 1898. The *Sarah* was built in Framilode, Gloucestershire, and registered at Bridgwater in 1923. Both are shown here at Bristol in their less glamorous barge style. *Sarah* was finally wrecked in 1947, and *Eliza* was broken up some two years later.

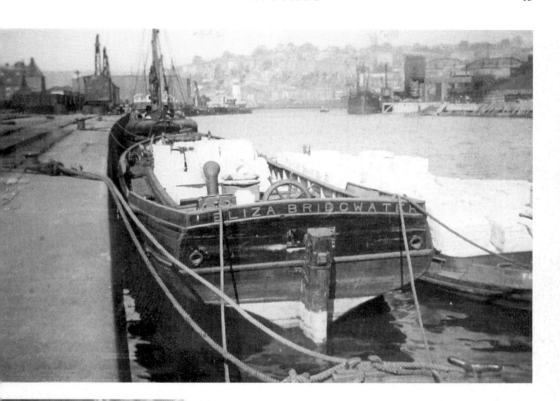

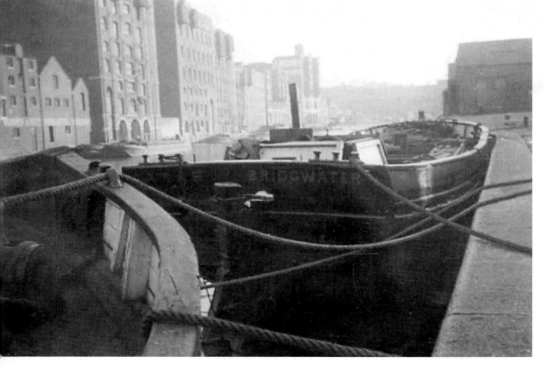

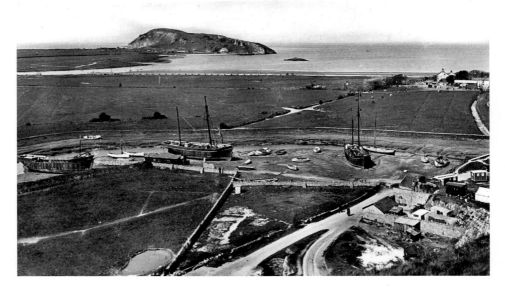

Uphill Wharf in about 1936 was the final resting place of three well-known local vessels. To the right is the *Norah*, a Severn trow built by John Gough of Bridgwater in 1868 and used for many years in the Bristol corn trade. She was finally owned by Captain Smart, who used her as a houseboat before she was given a Viking funeral in 1939. In the middle is the 1883 Goole-built ketch *Daisy*, owned by Captain Crockey, a retired seafarer who lived on the craft while she was laid up at Uphill. Bought for £5 in June 1938 by H. Penfold of Hewish, the hulk was filled with tyres and set alight, only her ironwork being salvaged. To the left is the 1890 ketch *R. Passmore*, built at Burton Stather and purchased as a hulk in 1938 for £4 2s 6d.

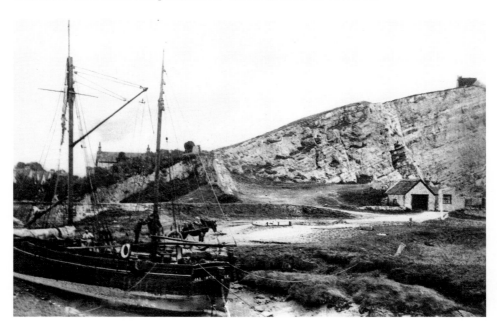

TWO

BURNHAM-ON-SEA

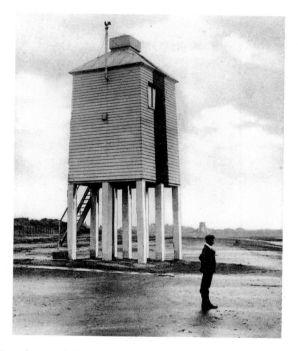

Constructed of Canadian teak in 1832, this 36ft high Burnham lighthouse stands on stilts on the sands and is unique in this country. The local authority maintains the structure now, having assumed responsibility from Trinity House when it became redundant in 1969.

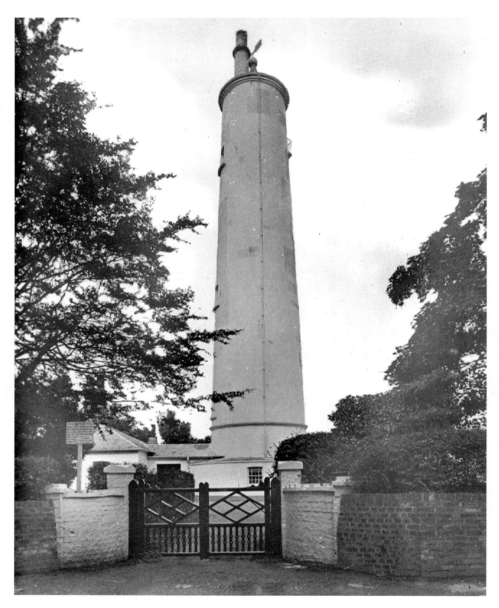

Also built in 1832, this lighthouse is 91ft above the high water mark. Both have a broad red line down the frontage and were built on the recommendation of Lt Henry Mongles Denham RN, who, having surveyed the entrance to the Bristol Channel, saw the need for such structures to ensure safe navigation off Burnham. This particular lighthouse was opened to the public before the First World War from 9.30 a.m. to one hour before sunset. Safe passage through the dangerous sandbanks obstructing the narrow entrance to the estuary required the pilot to bring his vessel into a position where the high light appeared directly above the low light. The latter gave out a red and white signal, while the high light shone with a plain white light for three minutes then darkened shutters obscured the light for 35 seconds. Captains thus had the different presentations of both lighthouses to effect correct navigation.

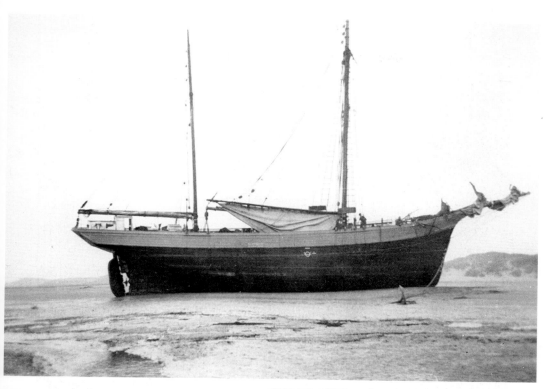

High and dry off Burnham-on-Sea in 1937, the ketch *Bessie Ellen*, built at Plymouth in 1907, had no option but to await the next tide to be refloated before resuming her journey. It is believed that this vessel was later acquired by Danish owners and renamed *Forsoget* and was undergoing extensive restoration. If this is right, it will be a joy to see her as she was when first launched and a familiar sight off Burnham shores.

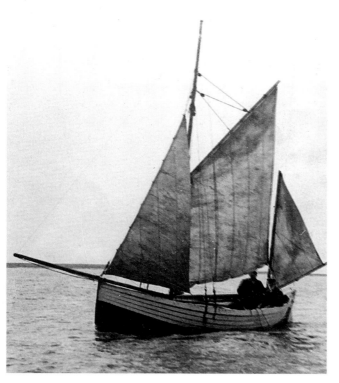

This picture from the Burnham slipway shows the *Lily*, one of the many Burnham pilot boats designed and built double-ended, two-masted and with bowsprit. These curved-sided, clinker boats would take the pilot out into the estuary in all weathers to give help to ketches waiting to be brought upriver on the incoming tide. Other pilot cutters providing identical service included the *Polly*, *Sunbeam* and *Star of the Sea*.

Below: This was a familiar scene from the seafront at Burnham-on-Sea at the turn of the twentieth century. A tugboat tows the three-masted topsail schooner *Gaca* as the steamship *Bauto* makes headway in the estuary.

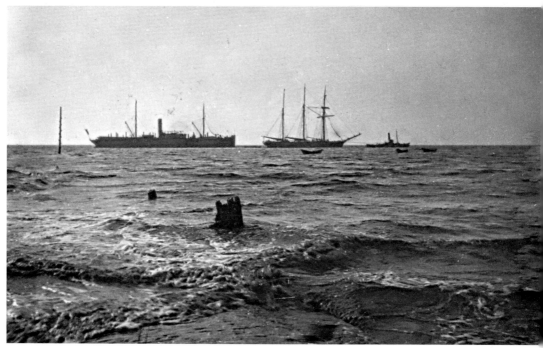

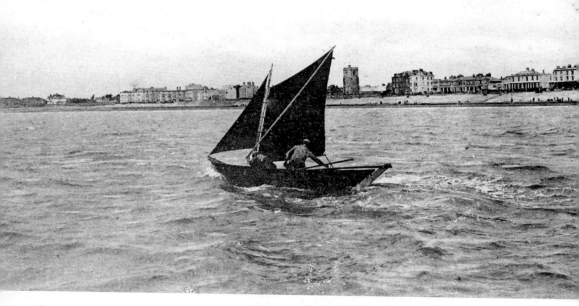

Flatners were double-ended open boats built in two sizes and ideal for use on the muddy banks of the tidal River Parrett. The 19ft 6in *Gore* is shown here off Burnham-on-Sea with her sprit-sail rig catching the prevailing wind. Two men were required to sail the craft, one to control the rudder and mainsheet, the other to control the jib-sheet and forward dagger board. Flatners, which were used throughout the year for fishing in the river or estuary as well as seagoing, were constructed of tongue-and-groove planks on a timber frame, and covered inside and outside with tar. A simple bolt and chain were used for towing. Henry Wilkins of Combwich and H.J. Kimber of Highbridge were the well-known builders of this craft, as well as the 16ft *Bay*. A smaller version of these vessels, usually about 15ft in length, was used on the rhines and ditches for carrying bundles or 'bolts' of harvested withies.

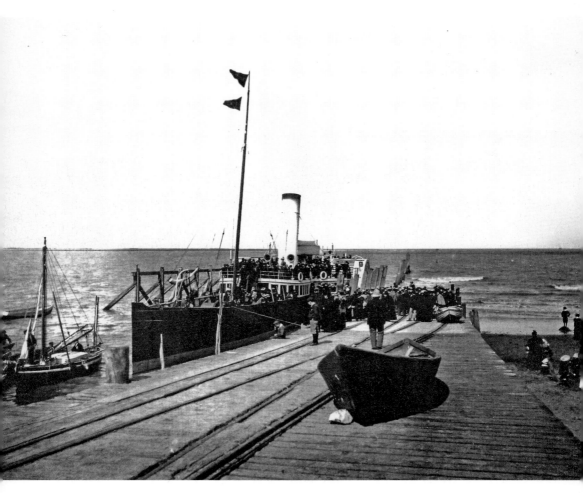

P. & A. Campbell's White Funnel Fleet steel paddle-steamer *Waverley*, built in 1885 by H. McIntyre & Co of Paisley, is seen here taking on passengers at Burnham-on-Sea pier in 1908. These boat excursions sailed the Bristol Channel to South Wales, the coast of Somerset and North Devon, the Holms, Lundy Island, and even as far as Bude and Tenby. Although competition with other companies was considerable by the 1920s the White Funnel Fleet had the lead. The *Waverley* was broken up in 1921 but the remaining paddle-steamers were used for carrying troops and for mine-sweeping during the Second World War, changing names for security reasons as had happened between 1914 and 1918. Two other paddle-steamers were named *Waverley*, one of which continues to provide pleasure trips from seaside resorts, including Dunball and other West Country places.

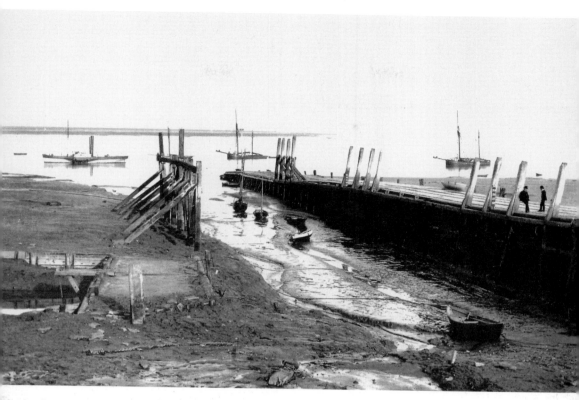

The landing-slip constructed between September 1857 and 3 May 1858, when the Burnham extension of the Somerset Central Railway was opened. The mooring piles alongside the jetty, together with the parallel line opposite, enabled ships to tie up alongside the pier. To the left foreground is the sluice-gate necessary to control the silt within the berth. Trucks would be pulled up the 1-in-23 gradient by wire rope attached through a ring from the pierhead to the nearby station. It was from this pier that Burnham lifeboat was launched on a rail bogie. In the background to the left is the steam paddle-tug *Petrel* awaiting high tide to tow several loaded vessels upriver as far as Bridgwater.

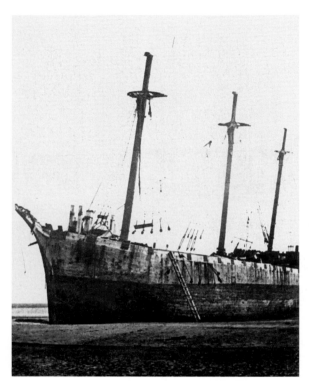

The Norwegian barque *Nornen*, built in 1876, dragged her anchors while moored in Lundy Roads during a storm on 2 March 1897. With snow falling, high winds and her sails in tatters she was driven ashore at Berrow Flats. The Burnham lifeboat, the *John Godfrey Morris*, was launched with a thirteen-man crew using her ten oars, but the *Nornen* had beached and the crew was safe. The coxswain, Mr Alfred Hunt, landed his crew and one dog at Burnham-on-Sea, where they were looked after by the Shipwrecked Mariners' Society. Attempts were made to lighten the barque but she was stuck fast and was later broken up on the beach. To this day her remains are visible when currents and shifting sands reveal the wreck at low tide near to Berrow church.

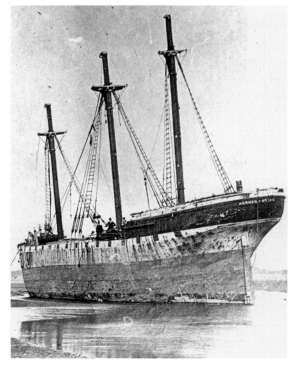

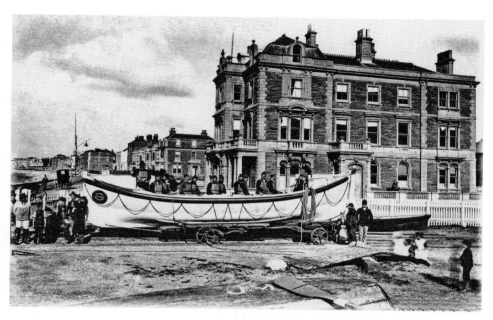

The 34ft water-ballast lifeboat *John Godfrey Morris* on the rail bogie from which she was launched at Burnham-on-Sea on 13 December 1887, thus replacing the *Cheltenham*. She continued in service until December 1902, when she was superseded by the *Philip Beach*, a Liverpool-type lifeboat.

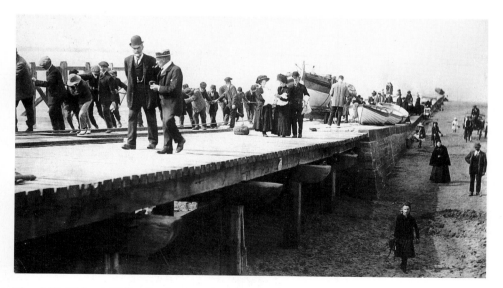

The 35ft lifeboat *Philip Beach* arrived at Burnham-on-Sea on 16 December 1902, and during service until 1930 saved at least five lives, later being sold for yacht conversion. This photograph shows the many helpers prepared to haul the boat on her rail bogie, stern first, up the steep slipway to the lifeboat house. How many men today would wear a suit and hat while walking on the beach and pier? How fashions change. . . .

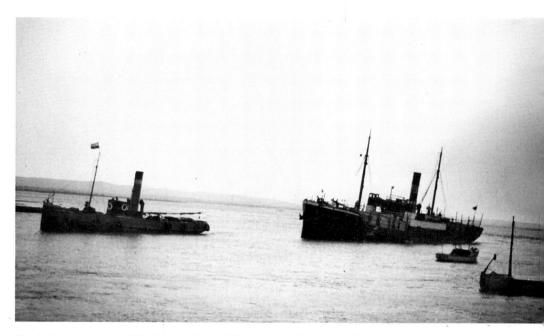

The listing steamship *Pelle* is towed carefully into port by the tugboat *Rexford*, her deck cargo probabl[y] having shifted during a rough passage at sea.

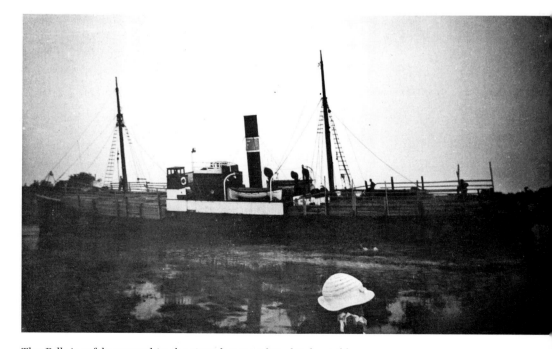

The *Pelle* is safely moored in the river, her port list plainly visible.

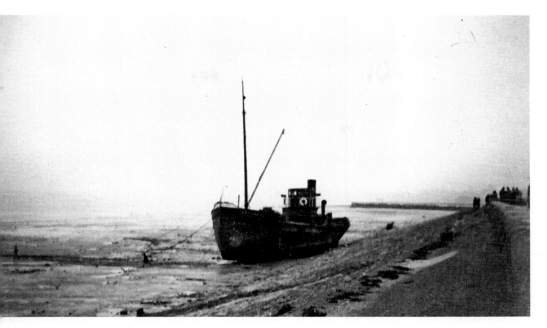

Onlookers watch and wait for the next tide as the safely anchored *Borderdene*, a small Bridgwater-registered steamship built in 1913, lies high and dry at Burnham.

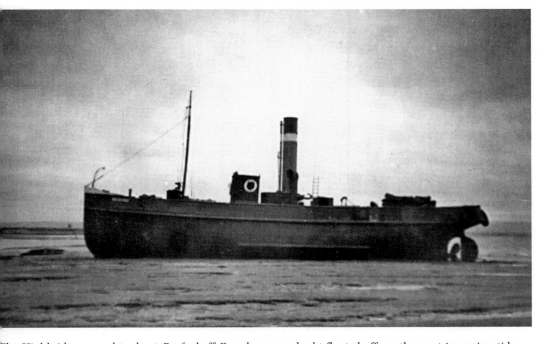

The Highbridge-owned tugboat *Rexford* off Burnham, no doubt floated off on the next incoming tide.

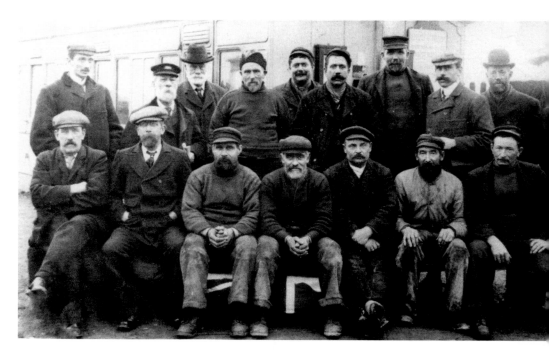

An old railway coach on Burnham pierhead known as the 'Cathedral' was used by, and provided food and comfort for the pilots and seamen of Burnham and Bridgwater. With a fixed table and a coal stove heated by fuel from local coal boats, the building served its purpose until it was replaced in 1938 by a new shelter, lit and heated by gas. The following well-known local names appear in the picture above: Mr Green (station master), W. Press, Captain Hunt, pilots Fred (Tich) King, J. King , T. Surfield, E. Brewer and ? Brewer. Among the front row are: Tom Parsons, G. Parsons, George Clapp and Jud Thomas.

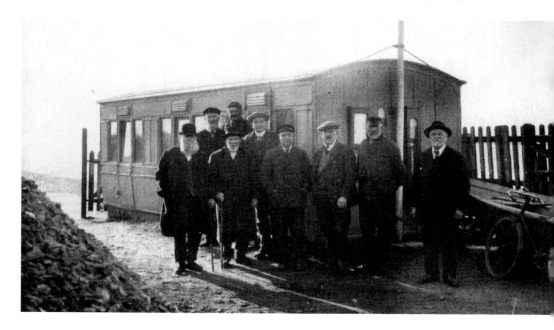

THREE

HIGHBRIDGE

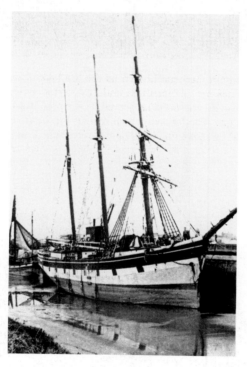

The Russian barquentine *Mercator*, 370 tons and 141ft long, was built at Haynasch in 1895 and is shown here at the Highbridge wharf unloading her cargo of timber from Archangel in September 1903. The decorative 'ports' were often painted on sailing ships of this period as a reminder of days when merchant shipping carried cannon for defence. The last cargo ship brought timber to this wharf in 1948.

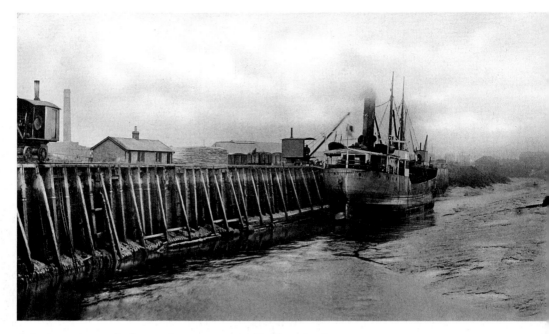

A foreign steamer discharges her cargo at Highbridge wharf.

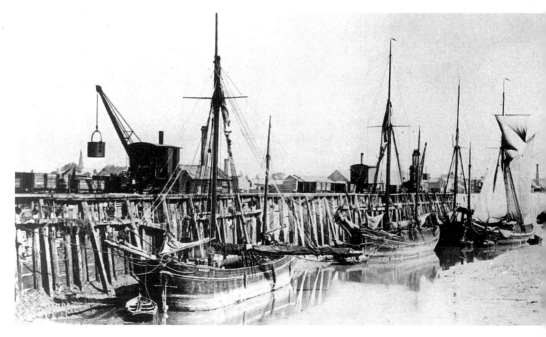

A turn of the century study of ketches and trows, sail and spars. In the foreground is the ketch *Galle*
with, behind, the Severn trow *Norah*, built in Bridgwater by John Gough in 1868. The *Norah* later becom
a hulk at Uphill in the 1930s and was burnt in 1939.

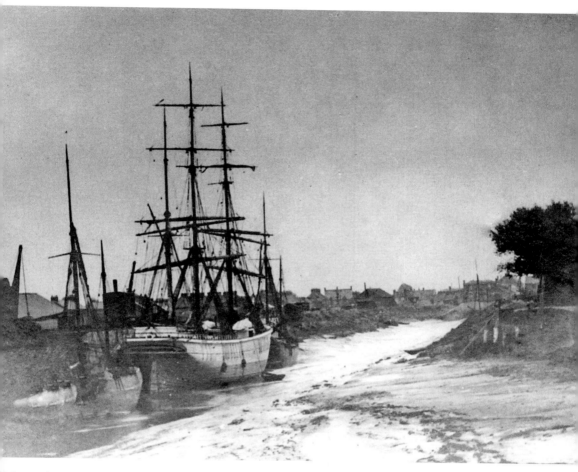

A large three-masted barque makes a majestic sight moored alongside Highbridge wharf with a ketch both fore and aft. While wine was imported, cheese and skimmed milk were exported to South Wales for the production of Caerphilly cheese.

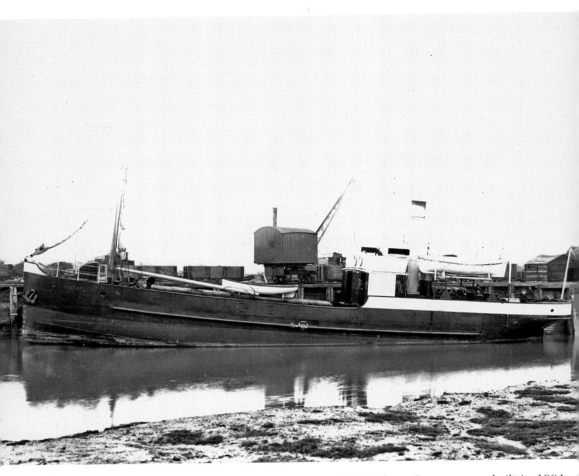

The steamship *Julia*, owned by the Somerset & Dorset Joint Railway Company, was built in 1904 at Woolston and was a sister ship to the steamship *Radstock*. Having unloaded her coal at Highbridge wharf she is seen here with her boat stowed on the hatches ready to catch the next tide. After thirty years she was broken up in 1934.

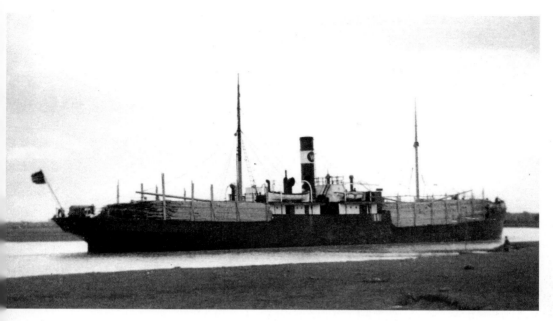

The Oslo-registered steamship *Primula* in the River Brue in 1938 stacked high with Scandinavian timber. This picture clearly shows the size of ships then using Highbridge wharf, which was closed to shipping in 1949.

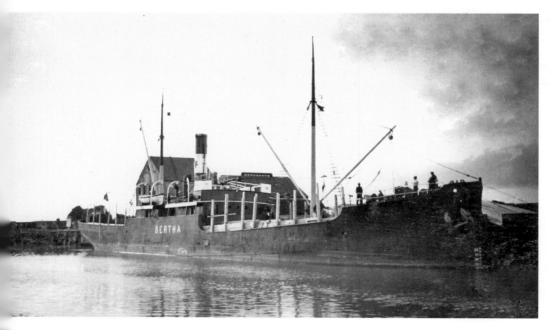

The steamship *Bertha* discharging her cargo at Highbridge wharf, the timber stacked high above the main deck held in place with numerous uprights. Visible are her booms, in use unloading the wood without need for shore-based cranes.

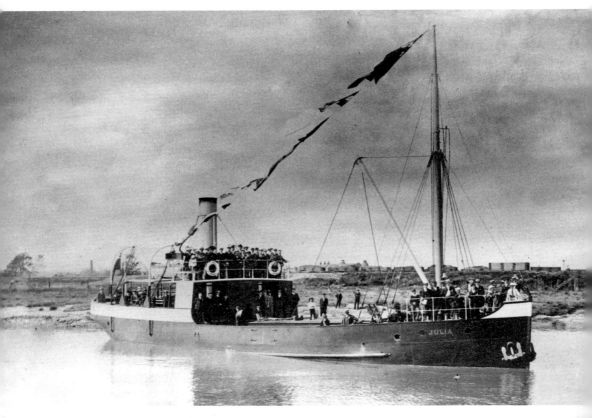

The steamship *Julia* bedecked with flags and bunting and displaying her signals as she makes her way to Highbridge wharf. This was her maiden voyage on 6 July 1904, and dignitaries and company staff can be seen lining the decks. She traded regularly from this port until she was broken up in 1934.

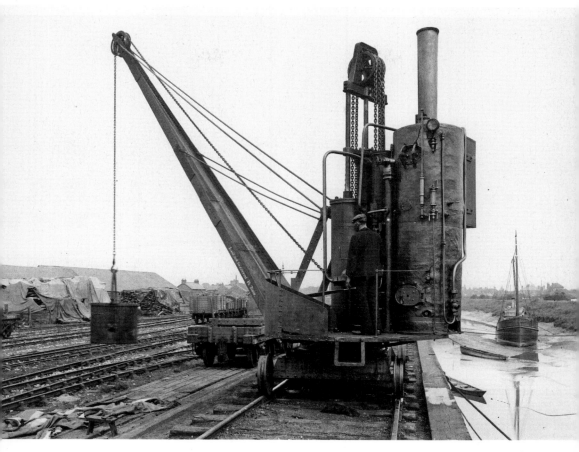

The 1½ ton steam-operated hydraulic lifting-crane was built in 1891, numbered 2, and belonged to the Somerset & Dorset Joint Railway Company. It is seen here working alongside Highbridge wharf, mounted and running on broad gauge track. To the right is the 1877 Bridgwater-registered steamship *Alpha*, also owned by the S&DJR and broken up in 1925.

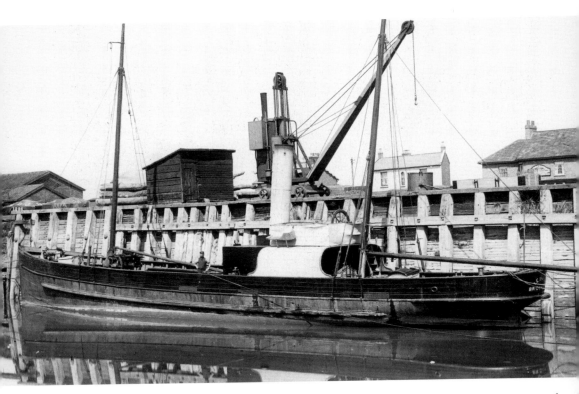

The steamship *Leopard*, registered in Bridgwater and again owned by the Somerset & Dorset Joint Railway Company. Built in Bristol in 1861, she was broken up in 1911.

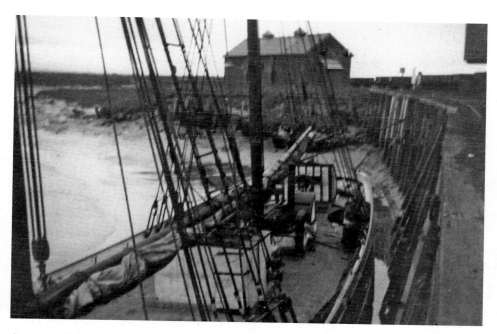

An unusual view captured in 1937 from the quayside at Highbridge wharf, with the Bridgwater-registered ketch *Sunshine* alongside. The main and aft hatch, ventilator, discharging gaff, main and mizzen masts and steering wheel are all visible.

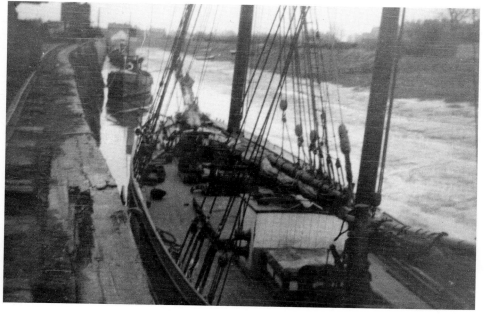

Sunshine photographed looking forward and showing her bowsprit.

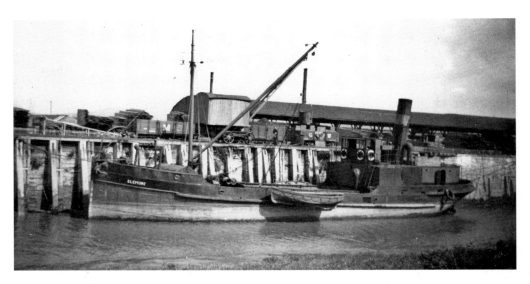

The steamship *Elemore* of Bristol alongside Highbridge wharf having unloaded a cargo of coal from South Wales by steam crane. Now sitting light in the river, her winch would have been used to stow her tender boat on deck before sailing on the next tide

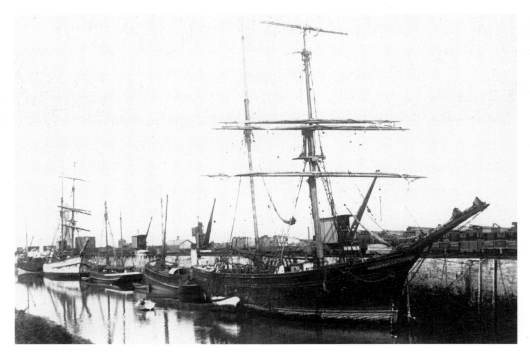

The 1874 brigantine *Livonia* at Highbridge wharf. The volume of trade here is obvious from the five vessels, sail and steam, loading and unloading cargo. Highbridge saw imports of wine, flour, coal, timber and iron rails, and exported bricks as well as skimmed milk. With hindsight, we now know that trade had peaked and at the time of this photograph, about 1910, was already in decline.

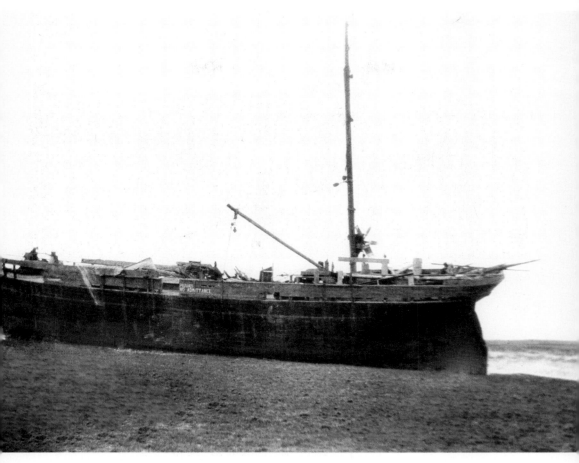

The hulk of the ketch *Marian* disintegrating on the mud in Highbridge river. Built in 1869 by John Gough of Bridgwater, finally she was given a Viking funeral by being burned deliberately in 1939.

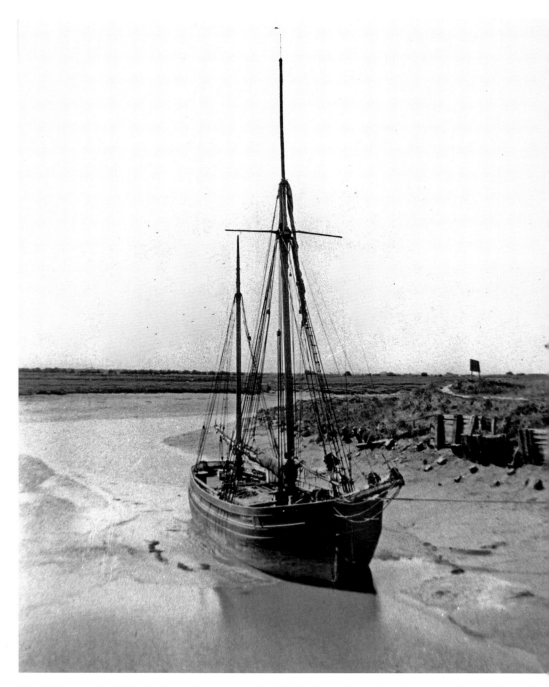

The Bridgwater-built ketch *Fanny Jane* aground at Highbridge Pill awaiting the next tide to discharge her cargo. The very rapid rise and fall of the tide made it easy to misjudge the time available for berthing and many boats suffered from a long wait before being refloated.

FOUR

COMBWICH

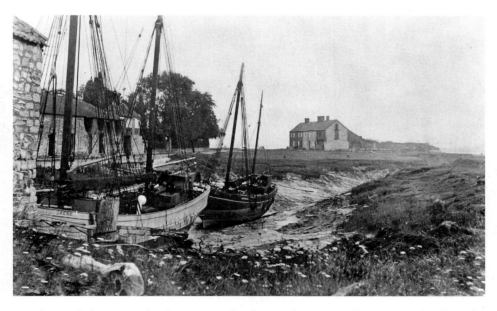

Bridgwater's famous and only surviving ketch *Irene*, here moored at Combwich Pill, and behind, the ketch *Woodcock*, built in Barnstaple by W.S. Kelly in 1895. Combwich was not only a trading port for many centuries, but was also known for the use made by local fishermen of dipping nets from 'flatners', 16 or 19ft long, flat-bottomed, double-ended boats with no keel. Henry Wilkins of Combwich was reputed to have built the best of these local craft, which could be used throughout the year and were sometimes equipped with a sail. They were a familiar sight to members of the local older generation.

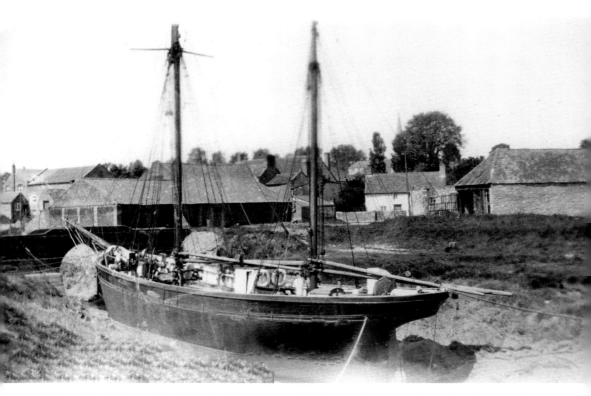

The rather forlorn sight of the ketch *New Design*, built at Bridgwater in 1871 by John Gough. It is seen here moored at Combwich Pill prior to sale, after which she was laid up at Bristol Bridge until 1946 and finally hulked in 1951. Her name derived from her style of construction with only half the usual number of ribs but of twice the usual thickness. Interestingly, she shows an unsheltered open wheel and a whale-backed lavatory-box on her starboard side.

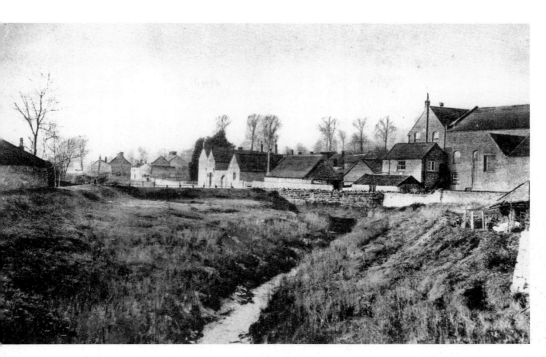

Vest End, Combwich, *c.* 1909.

The ketch *Woodcock*, built at Plymouth in 1895, was a regular sight at Combwich. She is pictured here on a calm high tide as her tender is lifted on board to be ecured to the hatches under the main boom prior to ailing, her discharging gaff lowered to deck.

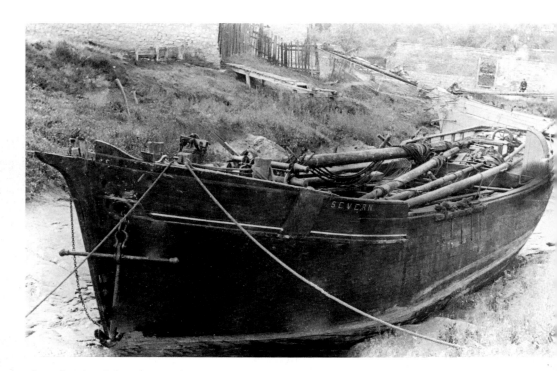

The sad sight of the 1867 Bridgwater-built trow *Severn*, hulked and dilapidated in her final resting place at Combwich Pill. As tides rose and fell over the years, her timbers sank deeper into the mud, and she slowly disintegrated until nothing was left. The bowsprit of the *Irene* is visible behind her.

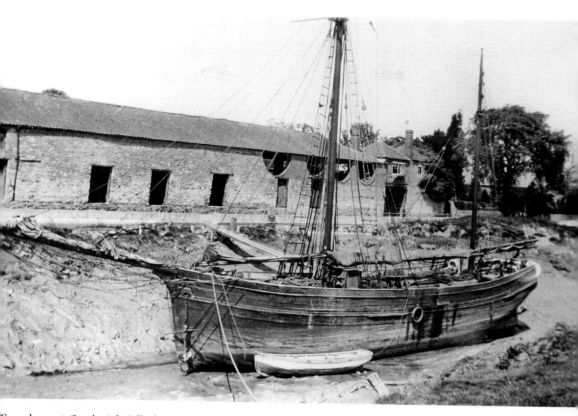

Seen here at Combwich Pill, the Bristol-registered ketch *Emily*, owned by Combwich & District Farmers' Association, was built at Chepstow in 1895 and foundered in the Bristol Channel. On Saturday 22 September 1934, while laden with coal, she capsized off Flat Holm in rough seas on a voyage to Bridgwater. Captain Thomas Granter of Combwich and deckhand Harry Davis of Polden Street, Bridgwater, survived, but the mate, Reginald Phelps of Bridgwater, went down with the doomed ketch.

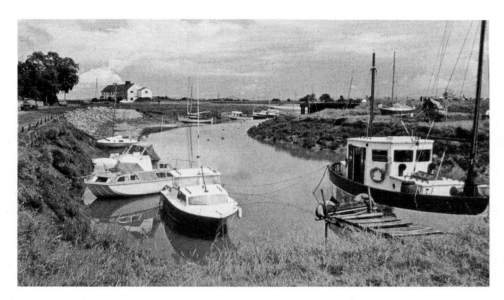

A more modern view of Combwich Pill, with leisure craft taking the place of ketches and schooners. To the right is the Port of Bridgwater's converted wooden motor trawler *Bridgwater Castle* built in 1945 at Bideford as the *Anncliveian*, and later called *Huntley Castle*. Renamed *Bridgwater Castle*, she was used for the inspection of buoys in Bridgwater Bay as well as general river maintenance, and for some years was moored in the Pill or beached on the opposite bank of the River Parrett at Pawlett Hams.

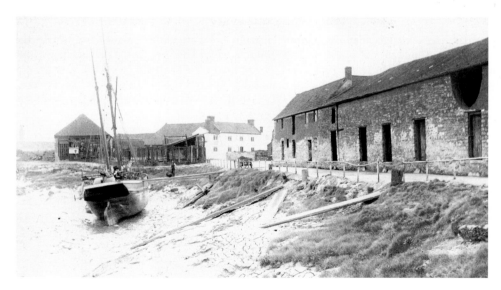

The 1878 Salcombe-built ketch *Sarah Jane* alongside Combwich Quay. Her discharging gaff pulled up on her mainmast shows clearly, and on the 'skid' a man with an empty basket waits to fill it with coal before it is swung out of the hold and unhooked. The ketch would then be cleaned before being loaded with bricks and tiles ready for departure. She was wrecked off Ilfracombe during the First World War.

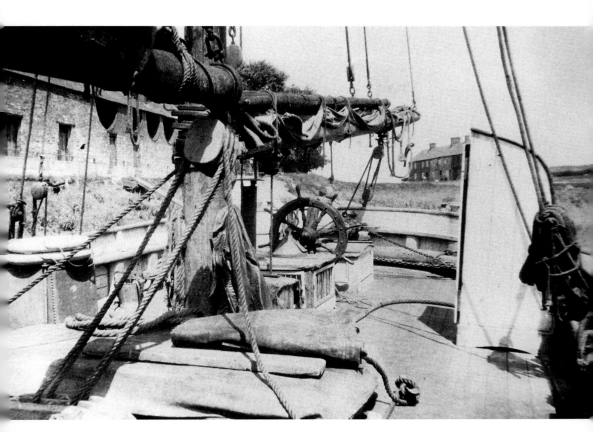

The Bridgwater ketch *Squirrel*, built in 1882 by F.J. Carver of East Quay moored at Combwich Pill. This unusual view, looking aft from the main hatch, shows the whale-back toilet shelter, aft hatch and canvas hatch-cover, skylight, ventilator, and, on the left, the fresh drinking water tank with two lifebelts secured on top. At the end of the main boom with its heavy treble block is the mizzen gaff resting on the mizzen boom, and secured with a double block attached to the stern rail. The open wheel had no shelter against the elements and sailors at the helm suffered from the lack of protection.

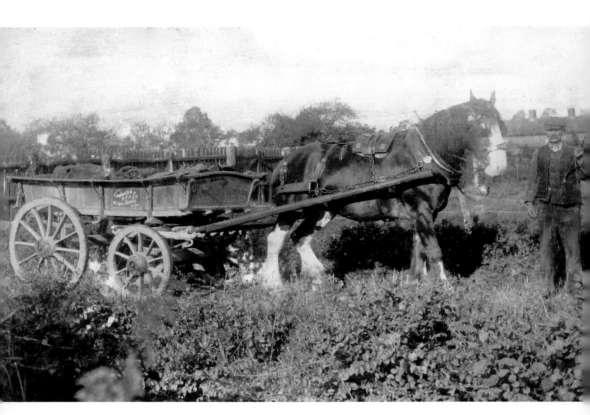

A horse and cart belonging to the Combwich & District Farmers' Association with its keeper in the local fields. The association owned a number of sailing vessels used regularly over the years by the farming communities to the east of the Quantock Hills and who traded out of Combwich with corn and produce, returning with coal and coke. The last Combwich-owned craft was the ketch *Emily* which was lost off Flat Holm on 22 September 1934 while bringing coal from Lydney for the Farmers' Association.

The motor vessel *Seatern* of Seaway Coasters Ltd unloading cargo at Combwich for the nearby Hinkley Point nuclear power station. This modern harbour installation, with its heavy-duty lifting crane belonging to Babcock & Wilcox Ltd, was specially constructed to unload cargo by ship and avoid the constant road transport problems of 'abnormal loads' from more distant places.

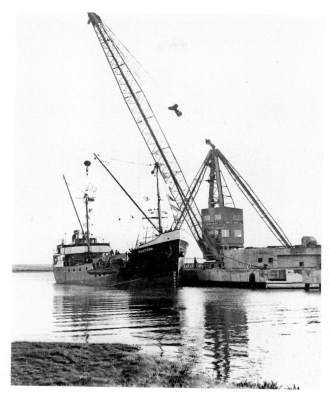

Unrecognisable today, the Anchor Inn was a favourite hostelry for seamen visiting Combwich Pill. At the time of this photograph the licensee was William Manchip, who provided 'Luncheons, Teas and all classes of Refreshments', which were no doubt very welcome after the hardship of long hours at sea in open vessels with little or no protection against the notoriously inclement weather of the Bristol Channel.

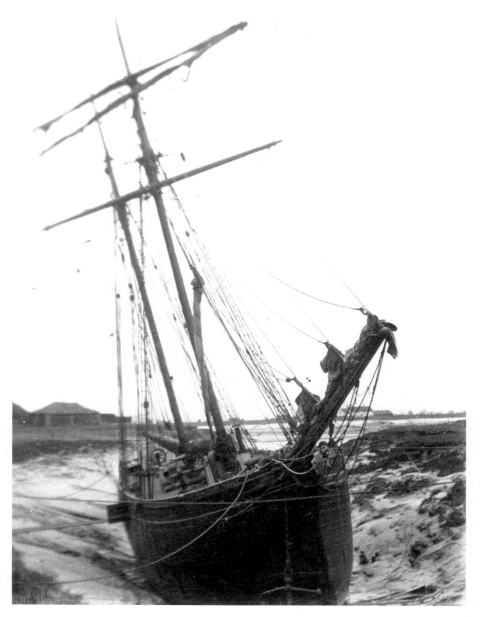

In 1878 John Gough of Bridgwater built this beautiful schooner, appropriately named *Princess of Thule*, shown here moored at Combwich in about 1910 with gangplank in position for loading and unloading. In the distance, visible below her bowsprit, is the now-demolished White House public house, which was on the east side of the River Parrett at Pawlett Hams. This was the crossing-point over the Parrett for pilgrims en route to Glastonbury, who used either stepping stones at low tide or, in later years, a ferry. The causeway, or 'cassy' as it was known, was still being crossed by horse-drawn wagons at the start of the twentieth century, but later, ferry boats carried sheep, cattle and foot passengers. This particular crossing saved miles of travel for people and animals alike since the nearest alternative was as far away as Bridgwater.

FIVE

DUNBALL

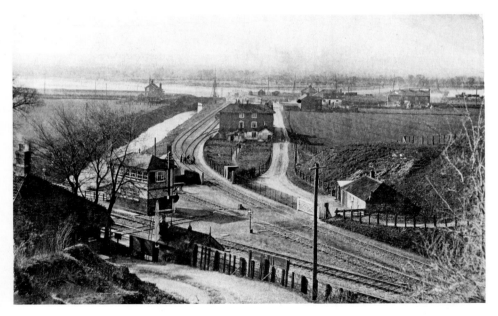

The main lines of the Great Western Railway and the tracks running into Dunball wharf.
Imports of coal, timber, sand and gravel were unloaded here for transportation elsewhere
by rail. Built in 1844 as a horse-worked tramway, the tracks were converted for steam
locomotives using both standard and broad gauge in November 1869, and in May 1892
to standard gauge only. Dunball wharf was extended in 1874 with an additional branch,
over which a 5mph speed limit was imposed. The author remembers how as recently
as the 1950s, a man with a red flag would halt road traffic on the main A38 Bristol to
Bridgwater road when a train with a maximum of twenty-five wagons was crossing. The
branch line, of some 792 yards in length, was closed on 19 March 1962.

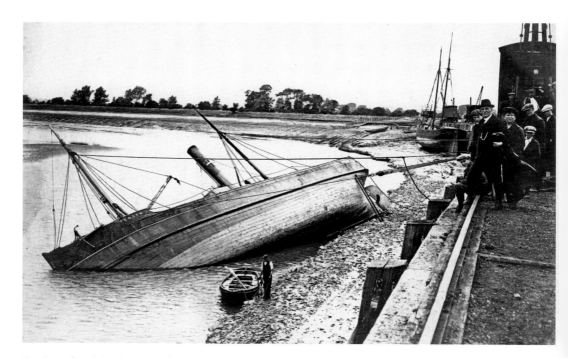

On Saturday 16 July 1921 the steamship *Tender*, belonging to Messrs Sully & Co. of Bridgwater, heeled over while being berthed at Dunball wharf with a cargo of coal from Lydney. It was not until the following Friday that a tug from Cardiff righted the vessel, a portion of coal having been emptied into casks placed on barges. The vessel, then much lighter, was towed stern up and righted on the ebb tide. No damage was caused by the incident and she continued trading until broken up in 1942, then sixty-nine years old, and in almost constant use since her launch.

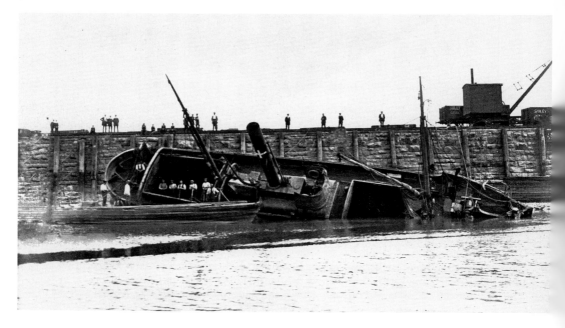

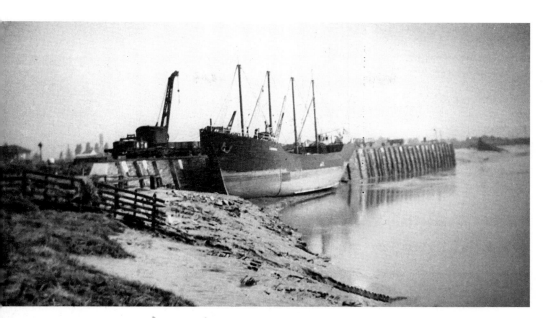

The unusual four-masted vessel *Laanemar* of Tallinn at Dunball wharf in 1936 after discharging her cargo of timber from Scandinavia.

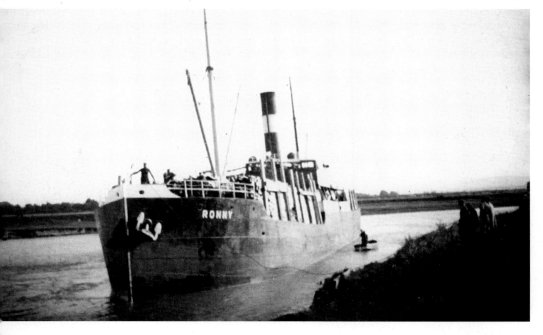

The steamship *Ronny* lists to starboard, having run aground off Dunball on a falling tide. A rope man in the bow appears to be about to throw a line ashore. This would be attached to a heavier rope and hauled to the bank to enable the ship to be made secure and thus avoid the possibility of her capsizing as the water level receded further.

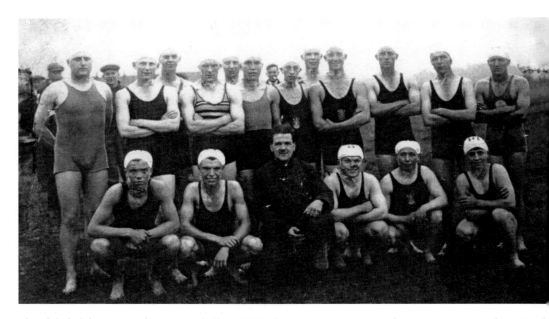

This delightful picture taken at Dunball in 1933 shows seventeen intrepid men just prior to their 5-mile swim from Dunball to the Town Bridge in Bridgwater. The men's full-length swimming costumes and skull caps were the height of fashion at the time!

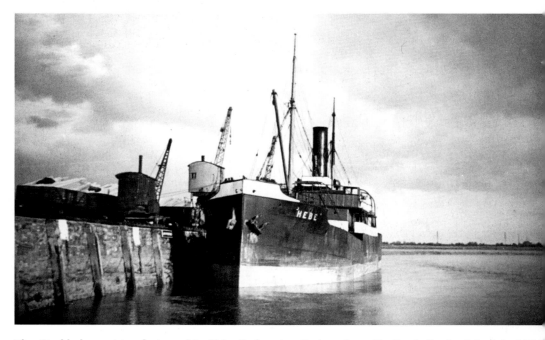

The Stockholm-registered steamship *Hebe* discharging timber alongside Dunball wharf in July 1938. The mobile steam cranes operating on track alongside the wharf were used to load to and from waiting railway trucks.

The graceful ketch *Emma Louise*, built in 1883 by William Westacott of Barnstaple, moored alongside Dunball wharf. After the First World War she was owned by the Rawle family of Minehead and traded between the Bristol Channel ports for many years. She was still in commission in 1948. With a jib boom and bowsprit, she carried a fine figurehead which was preserved and displayed at the North Devon Maritime Museum.

The three-masted steamship *Freza* of Kalman unloading her cargo of timber at Dunball wharf in 1948. Steam cranes and a saddle-tank locomotive can be seen alongside.

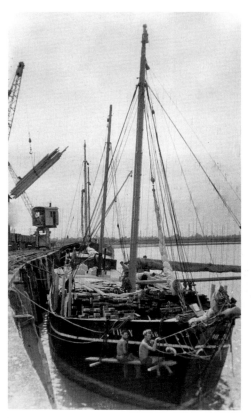

While a steam crane unloads a cargo of timber at Dunball wharf in the 1930s, a member of the crew occupies his time painting the hull of this Hamburg vessel. He is seated on a trestle suspended from the bow. The wharf was also used extensively for the discharge of coal shipped from South Wales to be distributed throughout the West of England by railway

Below: The Danish steamship *Olga* in difficulty. Having discharged her cargo of timber from Scandinavia, the pilot misjudged the tide, ran aground, and had to wait twelve hours before refloating on the next high tide.

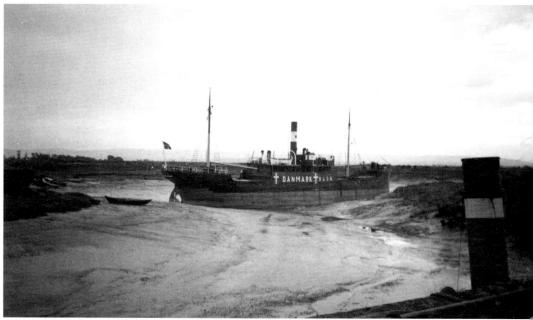

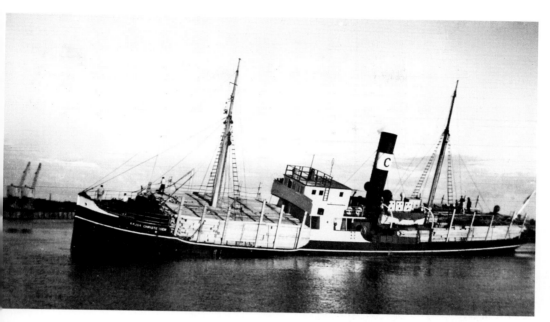

The steamship *Kajsa Christensen* off Dunball wharf having grounded in mid-river on an ebb tide. Heavily laden with Scandinavian timber stacked high above her decks, she lists to port at a precarious angle . . .

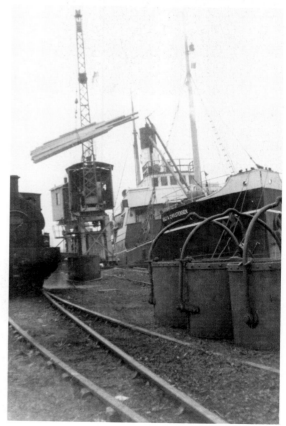

. . . however, she was able to berth safely on the following tide, and discharge her cargo.

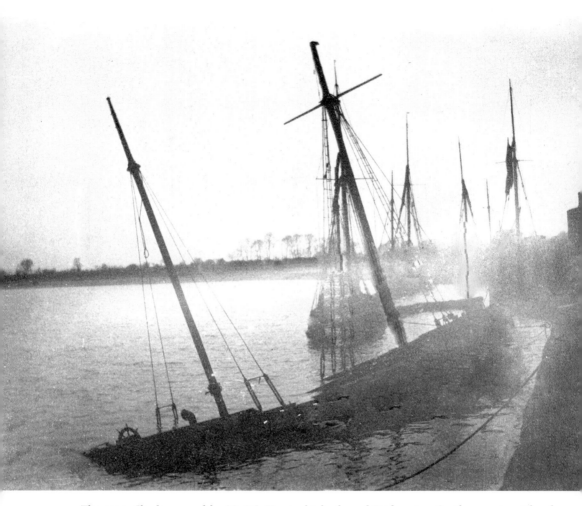

The trow *Charles* owned by Mr J.C. Hunt, shipbroker of Bridgwater. On the evening tide of Monday 19 November 1906, while bringing coal from Cardiff, she was brought upriver by Captain Britton and dropped anchor off Dunball, but with a strong wind and tide, the anchor chain fouled the windlass, the vessel's stern collided with the quay wall and her bows were badly damaged. Although two barges of coal were taken off the following day, the remainder of her cargo was lost. While the cargo was fully insured, the trow was only covered for a small sum.

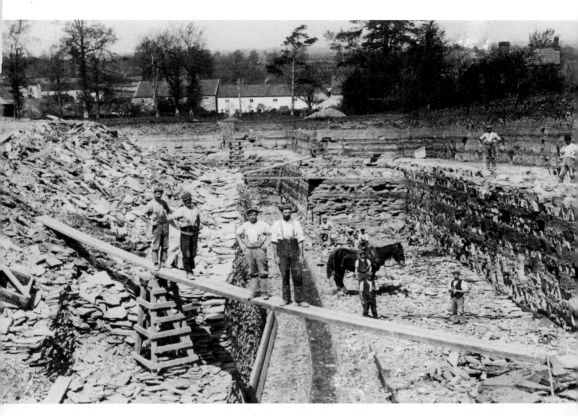

The labour-intensive occupation of stone quarrying at the Puriton works of John Board & Co. Ltd, with not a piece of machinery in sight! The layers of stone on the right were dug out by hand and loaded on to wheelbarrows which the workers then pushed down wooden planks, 18in wide and some 35ft long, supported around 30ft above the quarry floor on wooden trestles. No health and safety regulations in those days! The stone was used for cement and for the limekilns until they were closed in 1973.

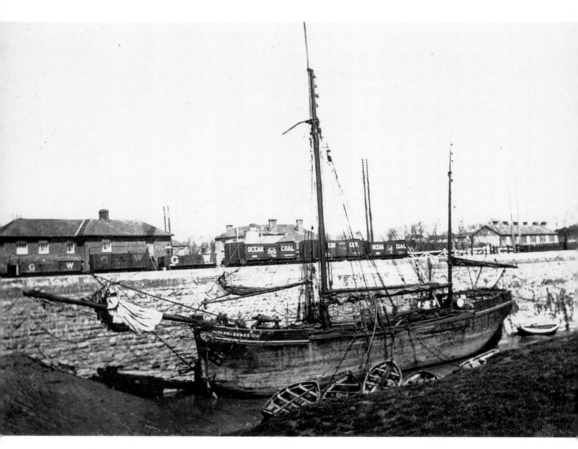

The *Prudence* was a typical Bristol Channel trow used for the transport of coal from Cardiff, Newport and Lydney to Bristol, Avonmouth and ports on the River Parrett. Seen here in 1910 at Dunball wharf, *Prudence* was built in 1822 at Beathall, Shropshire, in typical ketch style. Steered with a tiller, she had an open hold with no hatches but with canvas side-cloths in the absence of bulwarks except around her bow and stern quarters. As a result she was vulnerable in heavy seas and was used mainly in coastal waters. The small boat below her stern was reputedly used by one Jessie Ware who would place a lantern on Dunball Point for the benefit of vessels using the river in darkness.

SIX

RIVER SCENE

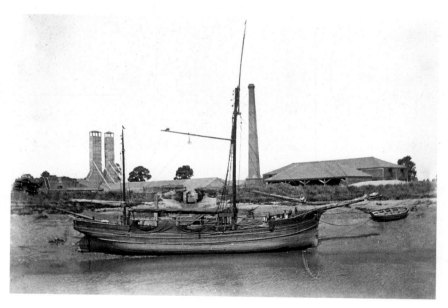

Built in 1901 by William Hurd of Chepstow, and Bridgwater-registered, the ketch
Edith is seen here berthed alongside Chilton Trinity brickyard while she is loaded
with bricks and tiles. Originally built as an open Severn trow, this photograph
shows the canvas side-cloths amid the bulwarks to the bow and stern, typical of
the trow. During a fierce storm on 13 July 1903, the *Edith*, captained by Mr M.
Warren of Bridgwater, sustained considerable damage when she turned completely
on her side after colliding with the landing stage at Brean Down quarries and had
to be towed to Bridgwater for repairs. On 8 July 1914 she was more fortunate
and suffered no damage running aground opposite Bridgwater Hospital and was
refloated on the evening tide. Motorised in 1927 she continued to ply her trade
until registered as 'unwanted' in 1960.

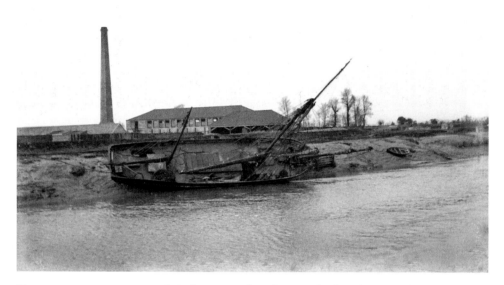

How not to secure your vessel! Built in 1867 by John Gough of Bridgwater, the 60-ton ketch *Fame* here lies capsized alongside the original Chilton Trinity brickyard of the Somerset Trading Company. Refloated successfully, she ended her days when she ran aground on the east bank of the River Parrett above Dunball wharf where, many years later, her remains could still be seen at low tide.

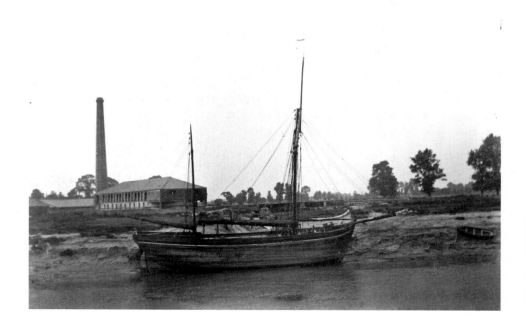

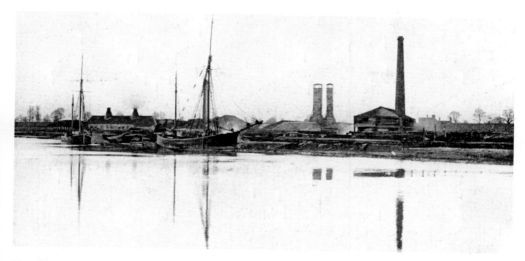

The Somerset Trading Company published postcards to advertise its premises at its Chilton Trinity tile factory. The reverse of this card details its products, namely Bath bricks and Bath brick powder. The 120ft chimney built with 85,000 bricks, was demolished on 30 December 1931 by the Bridgwater firm of Messrs Pollard & Sons. Timbers at the base were saturated with oil and tar and set alight. After just five minutes, the burning timbers gave way and the stack fell within 5ft of its intended location.

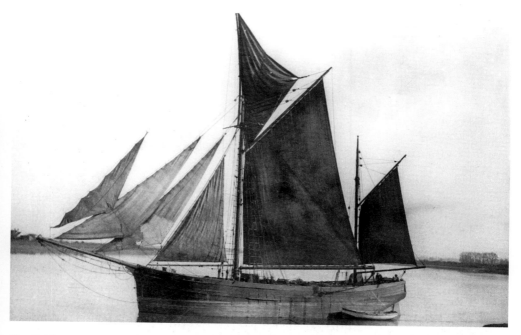

The Bridgwater-registered ketch *Emily* in full sail on the River Parrett. Tragedy struck in 1934 when she foundered east of Flat Holm and her mate, Reginald Phelps from Bridgwater, died. The captain, Thomas Granter of Combwich, and Harry Davis of Bridgwater survived when they were able to scramble into a dinghy.

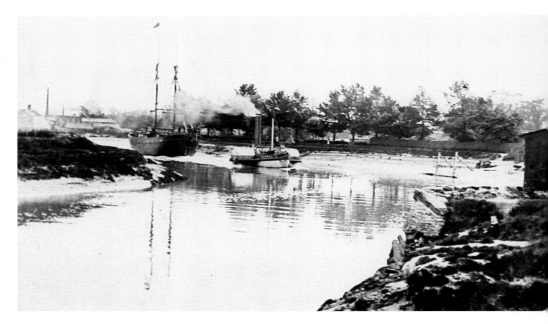

The steam paddle-tug *Petrel* built in 1863 at Low Walker, hauling the schooner *Rosevean* past Crowpill on a rising tide in about 1865. The *Rosevean* was built on the Scilly Isles in 1847 but in 1906 was hulked on the banks of the River Parrett.

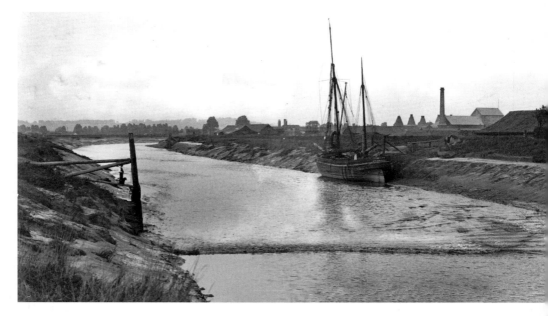

The tidal bore sweeping upriver at Saltlands, Bridgwater, in 1913, with the 1858 ketch *Fanny Jane*, built by John Gough of Bridgwater, securely moored at Colthurst Symons wharf. To the left is the wharf of John Symons & Co. Ltd, famous for making scouring bricks imprinted with the name 'Bridgwater Bath Brick Company'.

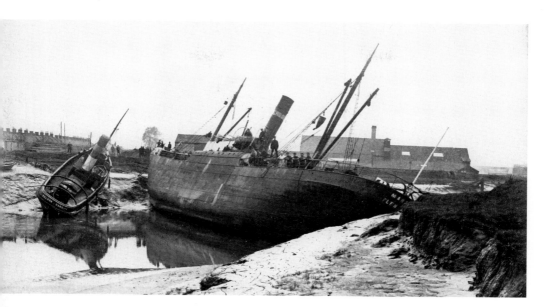

n a Tuesday in late November 1921 the steamship *Martha* collided with the ketch *Champion* at Dunball harf while being towed upriver. Later, while opposite the premises of the Parrett Bath Brick Co., the *artha* and the two towing tugs went aground, one of the tugs being jammed against the bank. On the orning tide the *Martha* swung across the river and completely blocked it to all other vessels. Some of er cargo was removed and on the Wednesday night she was floated upriver to Saltlands, where she ounded yet again! On Thursday she was refloated and, safely this time, proceeded into the docks where er cargo was discharged. Records indicate that the SS *Martha* was manned by a German captain and ew and that despite all these mishaps, she sustained no damage, no doubt to the relief of Bridgwater ipbrokers Messrs Charles Hunt & Co.

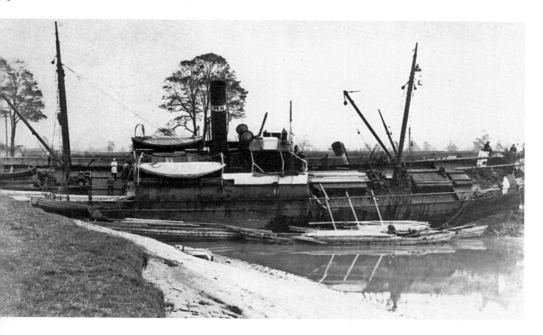

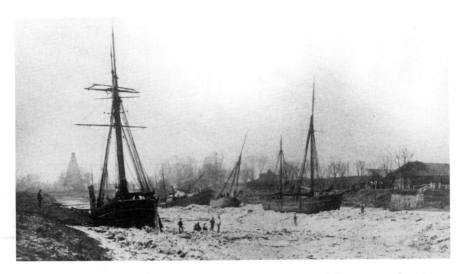

1 January 1880, and this chilly scene reflects the severity of the winter when it was possible to walk across the Saltlands area of the frozen River Parrett at Bridgwater. On the left is the schooner *Octavius*, built only two years earlier by F.J. Carver & Son of Bridgwater; next is the steam barge *Alpha*, built in 1877 and broken up in 1925. An unknown smack and a ketch complete the picture.

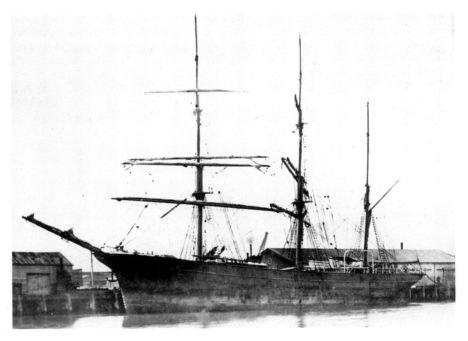

The *GBS*, a large 545-ton and 164ft long iron barque built in 1876 in Sunderland and named after George Bryant Sully, one of the well-known members of the Bridgwater family of coal importers. Proving uneconomic, she was sold in 1882 by Sully & Co. and later renamed *West Australian* of London. The location of this photograph is unknown.

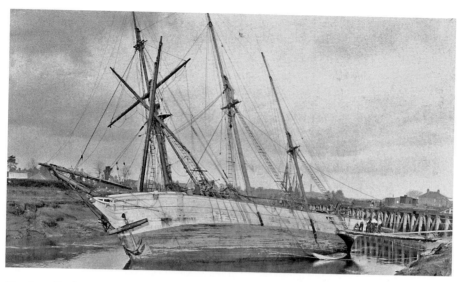

Nearing Bridgwater docks on 8 November 1908, the Norwegian three-masted brigantine *Eidsvold* of Frederickstadt was wrecked. The 313-ton vessel was heavily laden with deal boards from Norway for Messrs George Hooper & Co. Ltd, timber importers of Bridgwater. On reaching the mouth of the Parrett, she was taken in tow by the *Bonita* and *Victor* but, while only 200 yards short of the docks, an easterly wind cut the tide down to 2ft, which caused the vessel's bow to touch the west bank and the stern rope to part. The *Eidsvold* swung across the river and the stern embedded on the other side. Attempts were made to refloat her the following day but to no avail, so the deck cargo was taken off. She then sprang a leak and filled with water. A month and a day later she was auctioned as a wreck and was bought for the princely sum of £41 6s by a Mr Hurley of Bristol. She was then emptied of her remaining cargo and towed away by a Cardiff tug to be broken up by an Appledore shipbreaker. However, on the way to Appledore she made so much water she had to be taken into Penarth for safety.

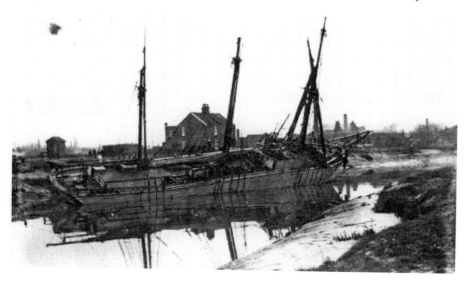

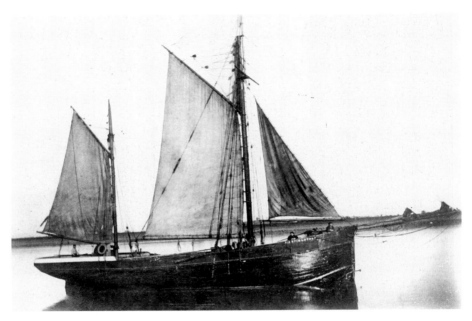

The unladen ketch *Martin Luther*, built in 1847 at Cowes and owned by Fred Penberthy of Weston-super-Mare, makes her majestic way up the calm River Parrett under full sail.

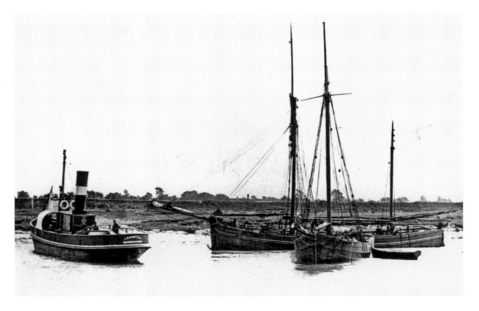

To the left of this photograph is the Bridgwater Steam Towing Company's tug *Bonita*, under her master Captain Smart, in the process of taking in tow the Severn-decked trow *Duke of Wellington*, as well as an unidentified smack. Up to six vessels would be taken in tow and brought upriver, different boats being cast off at various ports on the way. The *Bonita* was sunk off Liverpool on 3 May 1941 by bombs from a German aircraft.

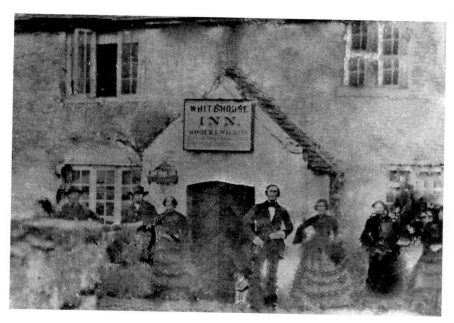

Alongside the bank of the river at the western end of Pawlett Hams, the White House Inn, last licensed in about 1911, was a familiar landmark to navigators on the Parrett until it was demolished in about 1930. This very early photograph was taken on a glass negative some time in the 1850s with the then licensee Robert Wilkins standing outside. A causeway led down to the river bank, which afforded crossing on foot or saddled horse at low tide or by ferry worked from Combwich.

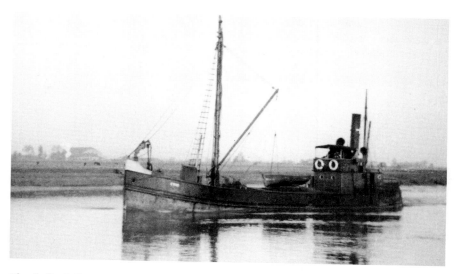

The Sully & Co. steamship *Enid*, built in 1903 at Maryhill, makes her way upriver on a fast-flowing incoming tide to Bridgwater docks to unload her cargo of coal from South Wales. She was a familiar sight on the River Parrett during the 1940s and '50s until she was broken up in 1959.

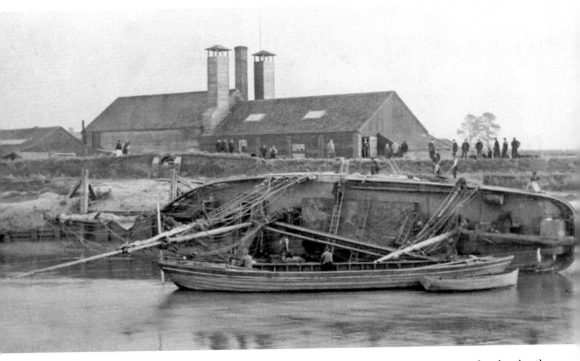

On Thursday 16 October 1910 the ketch *Arthur* of Bridgwater was being towed to her berth opposite the Parrett Bath Brick Co. yard. On being released from the tug, the tow rope fouled its anchor as it was being lowered and, with a strong wind blowing, the *Arthur* went aground on the bank. When the tide receded she heeled over on her side, her masts parallel with the water. The next day, with ropes attached to her side and with the assistance of a Parrett barge floated under her masts, she was pulled into an upright position and was ready to sail again, having, quite remarkably, sustained little damage.

The topsail schooner *C. & F. Nurse* was built in 1900 by Lean of Falmouth for the Nurse family of Bridgwater and is seen here loading alongside the brickyard of John Board & Co. After the Second World War she was owned and commanded by Captain Kelly of Nether Stowey and was the last locally owned schooner. Subsequently she plied her trade as a barge under the name of *Enterprise* before being laid up in the Gloucestershire canal for some years and finally broken up in 1955.

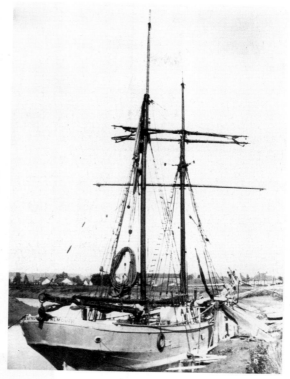

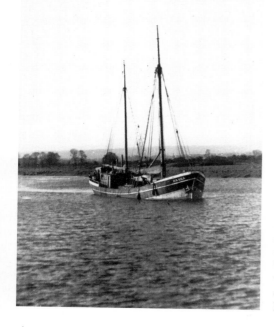

Originally built as a two-masted schooner at Waterhuizen in 1915, the Poole-registered *Hanna*, under her own auxiliary engine, makes her way upriver to Dunball in 1948. This lovely boat was wrecked off Jersey in 1949 while on passage from Plymouth loaded with limestone.

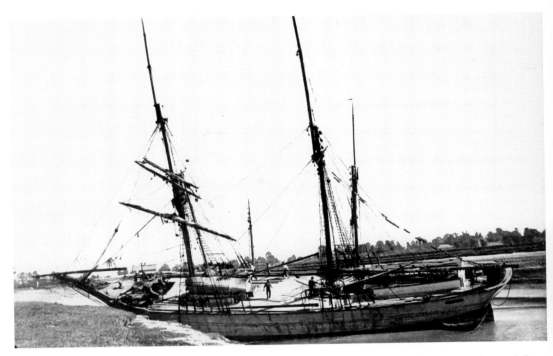

On Saturday 27 August 1904, while being towed up the River Parrett with a cargo of wood from Westwick, the Norwegian barque *Punctum* ran aground at Second Pound Field, some 1½ miles below Bridgwater docks. Crowds gathered on the Sunday evening to watch tug boats pull her off on the high tide so that she could be taken into the dock.

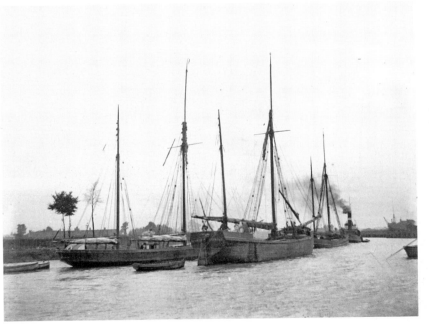

What must have been a familiar sight in years past is shown in this photograph taken at Saltlands of the steam tug *Bonita* towing three ketches from Bridgwater towards the mouth of the Parrett. Left to right are the *Annie Christian*, *Spartan* and *Fanny Jane*.

On 28 August 1948 the ketch *Emily Barrett* went aground on a mudbank off Horsey Pill near Dunball. Built as a schooner in 1913 by the Duddon Shipbuilding Company of Cumberland, and named after a member of the Duddon family, she was said to be the last merchant sailing ship ever built. She served as the hulk for a barrage balloon in Falmouth harbour during the Second World War, before being fitted with a new keel and keelson and re-rigged as a ketch, part of the work being carried out at Appledore. She was used extensively for carrying coal from Lydney and also bricks from Bridgwater.

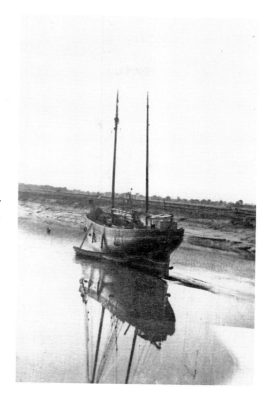

The hulk of the 451-ton *Biland*, built in 1865, shown here on the bank of the River Parrett.

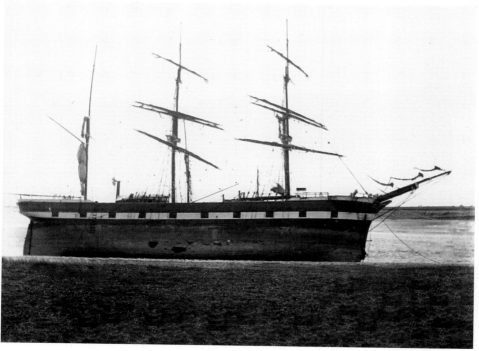

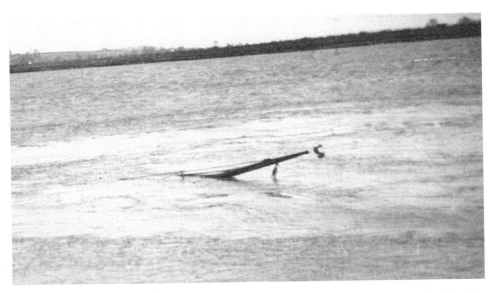

In March 1939, the ketch *Trio*, under Captain Warren of Bridgwater and on the ebb tide, accidentally grounded on the edge of a mudbank just north of Combwich known as 'Pursey's Mare'. As the tide receded the *Trio* fell over and proved a total loss. At high tide only the cockerel on the top of the mast was visible, as shown in this photograph. Built in Jersey in 1877 as a schooner, she was owned later by the Escott family of Watchet and then the Slade family of Appledore, who re-rigged her as a ketch. It is worth a visit to the area at low tide when it is sometimes possible to see her few remains.

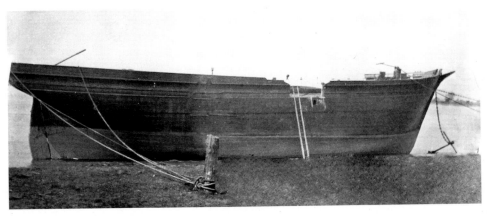

The schooner *Rosevean*, built on the Scillies in 1847, was hulked on the banks of the Parrett in 1906.

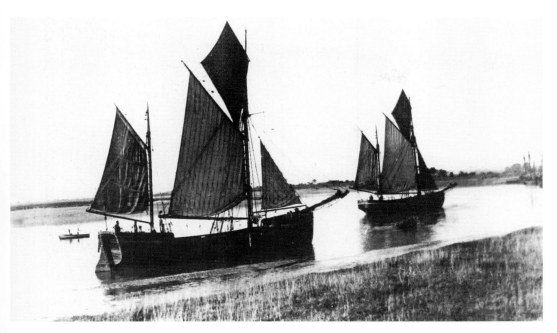

The difficulties of navigating the River Parrett could not be more clearly illustrated than in this view of the ketch-rigged Severn trow *Ark*, which has just run aground a mile below Bridgwater docks. A small boat, which was always towed behind vessels in the river in anticipation of this kind of incident, would have been hastily sculled to deeper water. A kedge, or anchor, would have been dropped to enable the *Ark* to pull herself off. Ahead of the *Ark* is the 1858 Bridgwater-built ketch *Fanny Jane*, wrecked in 1963.

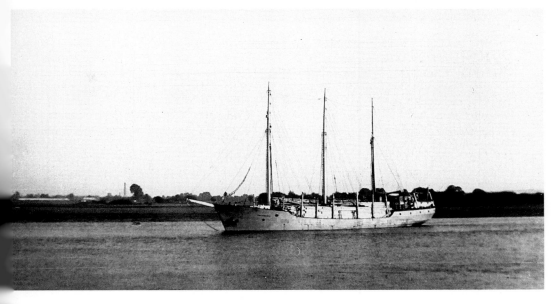

The three-masted *Ann Charlotte* bringing timber to Bridgwater in July 1949.

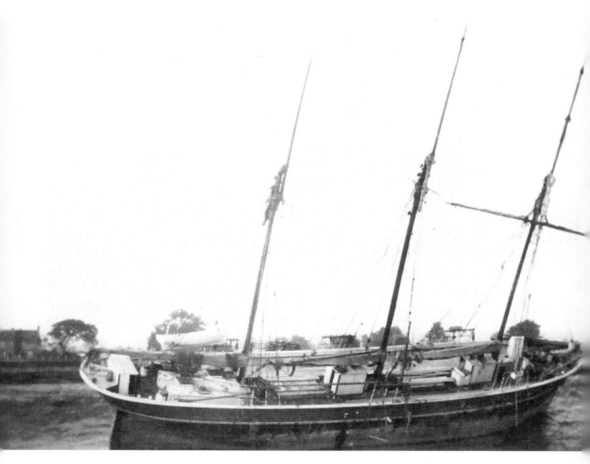

The 500-ton Danish sailing vessel *N.P. Peterson* from Archangel, with a cargo of timber for Messrs Hooper & Co. of Bridgwater, arrived late on the morning tide of Saturday 7 September 1929 at Little Reach, about 1½ miles below Bridgwater docks. While being towed by two tugs, she grounded on the bank and, as the tide continued to recede, she developed a decided list. Two barge-loads of timber had to be removed before she could be refloated on the night tide. However, after only 100 yards and in darkness, she grounded on the flood tide on the opposite bank. A further 200 tons of cargo was removed, but it was not until a week later that she was finally refloated and able to sail on her way.

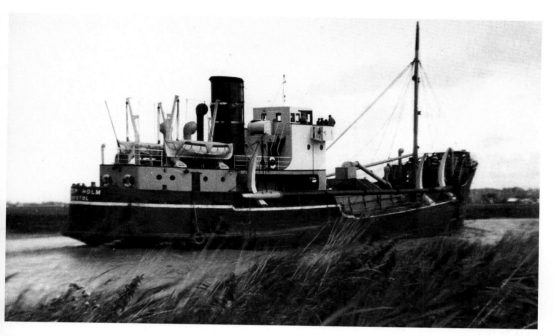

The suction sand dredger *Steep Holm* belonging to the Holms Sand & Gravel Company makes her way downriver after discharging her cargo at Bridgwater docks.

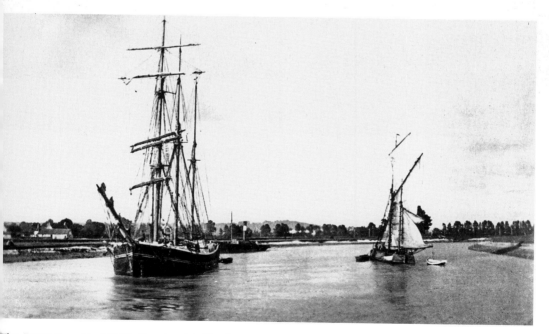

The River Parrett at Little Reach with Hawkers Farm to the left. At high tide a barquentine uses her auxiliary power while outward bound, and a ketch, low in the water, makes her way upriver. A steam tug is visible between them.

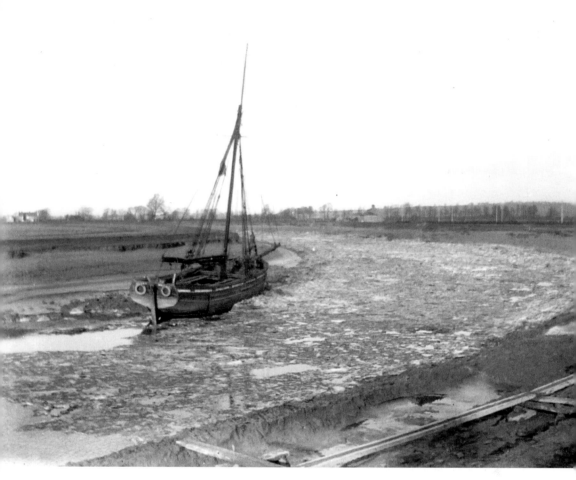

The Bristol-registered trow *Flora*, empty and aground on ice at 'Pondfields' during a severe winter. In the distance to the left is Hawkers Farm, with the A38 Bristol to Bridgwater road on the right. In March 1909, while owned by Captain Webb of Dunball, the master of the *Flora* tragically was lost overboard during a gale off the Holms when she was being sailed from Bridgwater to Cardiff loaded with coal. Apparently her tiller swung round and knocked Captain William Britton of Bailey Street, Bridgwater, into the sea. A gallant attempt to rescue him was made by the mate, Frederick Bawdrip, who lowered a boat to reach the master mariner, but failed to bring him on board. Captain Britton left a wife and nine children.

SEVEN

BRIDGWATER

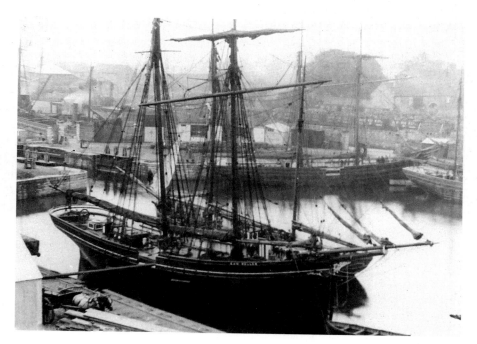

On Saturday 7 September 1872 the schooner *Sam Weller*, built for the Bridgwater firm of Brown & Co., was launched from the Bridgwater shipbuilding yard of John Gough at Crowpill in the presence of a large number of spectators. This vessel only had a short lifespan, foundering in 1899. The two yards on her foremast clearly distinguish the schooner from the ketches familiar on the river and in the docks. The bulwark, when removed, allowed a plank to be inserted on her starboard side which facilitated the loading and unloading of cargo. To her outside is the ketch *Clare Felicia* of Caernarvon, built at Nevin in 1873.

THE SULLY FAMILY IN BRIDGWATER

One of the oldest and most important commercial firms in Bridgwater was that of Sully & Company, ship owners and coal factors. Thomas Sully, always interested in the shipping trade, was born in Watchet in 1767 and moved to Bridgwater soon after 1800, the larger port offering better facilities than his home town. He died in July 1824 and was buried in Watchet. He left his property, including his prize brigantine *Brothers*, in trust for the benefit of his children, and two years later his eldest son, also called Thomas and aged twenty-three, started the business of Sully & Company.

The opening of the Bridgwater and Taunton Canal in 1827 enabled coal, imported from South Wales, to be distributed by barges to places along the waterway. Trade expanded further with the construction of the Bridgwater docks in 1841 and the subsequent development by the Bristol & Exeter Railway of the wharves and sidings at Dunball leading to the company increasing its shipping fleet to meet the need for coal.

In June 1845 James Wood Sully, brother of Thomas, joined the firm, which became known as 'Thomas & J.W. Sully'. In 1855 shipbroking was separated from the coal business, and George Bryant Sully, eldest son of Thomas, operated in the name of 'Sully & Hurman'. He died in Brussels in 1907, aged seventy-six.

In 1849 James and Thomas had bought a third share in two Forest of Dean collieries, 'Parkend' and 'New Fancy', acquiring a further third interest from Thomas Nicholson of Lydney in 1858. With the purchase of the final third in 1860 from Mr Trotter, they became the sole owners and traded as Parkend Coal Company. In 1860 Thomas retired and James Wood Sully became sole proprietor of the coal company. In the same year the name of the firm was shortened to Sully & Co. Thomas Sully died in 1861. The three sons of James Wood Sully, Thomas, John George and Richard Owen, entered the business and on 30 June 1876 James Wood Sully transferred all his interest in Sully & Co. to his three sons, but retained the Parkend Coal Company in his own name. His son Thomas died on 31 October 1877, aged thirty-three, and was buried in Lydney. In 1880 the firm owned 300 rail wagons, 20 sailing ships and 2 steam boats, but in that year the collieries were sold as the existing seams were worked out and the cost of sinking lower seams was prohibitive. James Wood Sully died in 1886 at the age of seventy-nine and in the home of his son John at Mount Radford, Bridgwater.

The opening of the Severn Tunnel in 1886 led to a decline in shipping so the sailing vessels were reduced in number, but the rail wagons increased to over 600 and a third steamship, the *Welsh Prince*, was purchased to complement the *Bulldog* and *Tender*. GWR broad gauge became standard gauge, and in 1892 the Sully wagons were altered at Swindon. In 1894 John George Sully retired to live at Clevedon and his brother Richard Owen Sully became managing director of the private limited company. His cousin J.W. Sully junior, a younger son of the remaining founder, became and remained a director until his death in 1900.

Thomas J. Sully, eldest son of Richard, joined the firm in 1893 and by 1903 was manager at Bridgwater. During the First World War the firm was appointed by the Government to control the distribution of coal in the Somerset area. By 1921 the coal trade had been deregulated and reverted to private enterprise, but changed conditions increased railway rates and dock charges seriously affected the transportation of coal

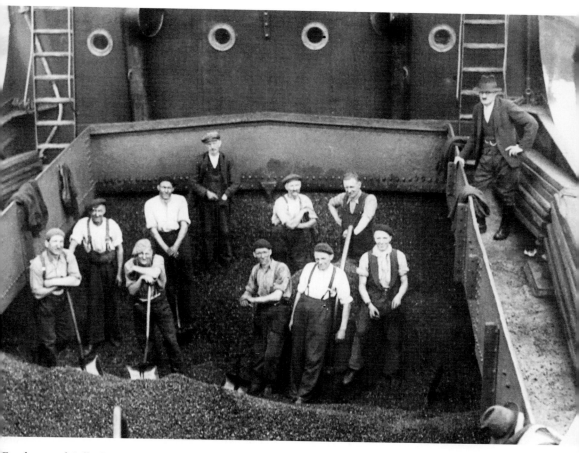

Employees of Sully & Co. rest on their shovels while the photographer captures the dirty and back-breaking task of unloading coal from the hold of the steamship *Crowpill* at Bridgwater docks. The wooden hatch-covers are shown on each side of the deck.

by water. Practically the whole undertaking became rail-borne and Bridgwater, as a port for the distribution of coal in the West Country, almost ceased to exist.

On 12 January 1928 Richard Owen Sully died aged seventy-eight, leaving a wife, two sons and three daughters. On 10 June 1935 John George Sully died at Clevedon, aged ninety, the last surviving son of James Wood Sully. He left a wife, seven sons and two daughters. Between 1935 and 1967 boats carrying the trademark of Sully & Co., a black funnel with white St George's Cross, continued to berth at Sully's wharf on the south side of the outer or tidal basin of the docks. The wharf closed in 1967 but the vacant site continued for years to be referred to as 'Sully's Yard' until redeveloped for housing. In 2010 a ceremony took place on the docks when a blue plaque was unveiled on the wall abutting the former 'Sully's Yard' to commemorate the long history of the Sully family and its contribution to the trade and economic growth of Bridgwater.

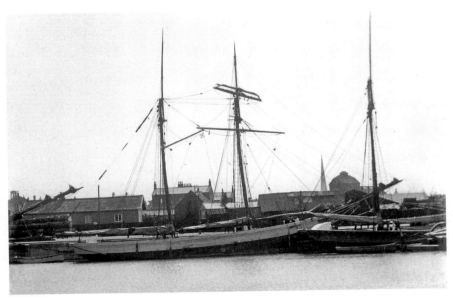

The steeple of St Mary's Church is just visible between the rigging of the schooner *Perriton*, built in 1881 on the beach at Minehead by Watchet shipbuilder Ben Williams for Thomas Kent Ridler of Minehead. She took eighteen months to construct and was the first ship built there since 1798. She was sunk on 29 January 1918 by gunfire from a German submarine, fortunately without loss of life.

A unique view of three double-ended Parrett barges riding the tidal bore at Crowpill, Bridgwater. The oar, or sweep as it was also known, was used as a rudder, or like a punt pole, to steady the craft. When the weather allowed, a small square sail was occasionally set.

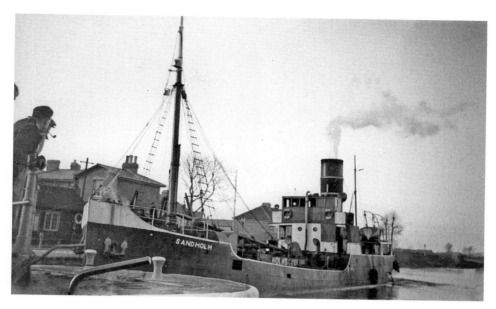

A nostalgic view of a pre-war steamship as she is manoeuvred through the narrow lock entrance to Bridgwater docks. The Holms Sand and Gravel Company's suction dredger *Sandholm* is seen here as she returns from the sandbanks of the Bristol Channel. She had dredged up her cargo of 500–600 tons, and would discharge it at the western end of the inner basin to the docks, while ships arriving at the quay alongside the dock and canal office near Dock Cottages would be recorded. The author remembers many a happy hour spent watching the pilot and employees of the dock company exercising their skills in bringing the ships into the tidal dock with only inches to spare on either side.

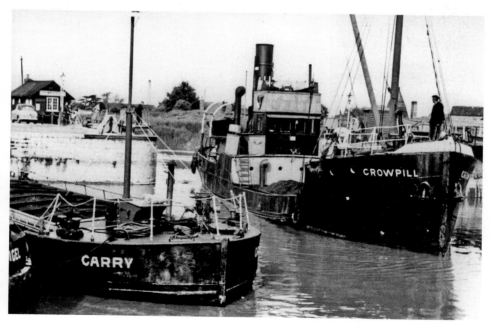

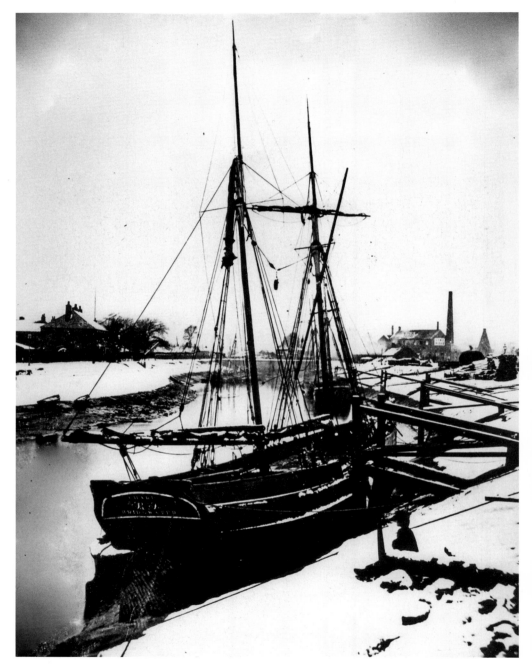

An early photograph taken in about 1865 of the schooner *Chard*, built at Bristol in 1844 and registered at Bridgwater in the same year. In May 1880, while carrying slate from Portmadoc to Southampton, the crew of this vessel, including Captain Jones of Highbridge, had to abandon ship, but they were rescued by the Norwegian barque *Tetens*. This photograph was taken before the construction of the telescopic bridge near Barhams Brickyard in 1871.

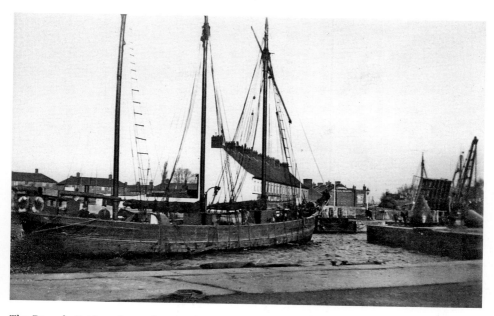

The Bascule Bridge, shown here with the Irish three-masted motor schooner *M.E. Johnstone* leaving the floating dock and entering the tidal basin for the River Parrett and the open sea.

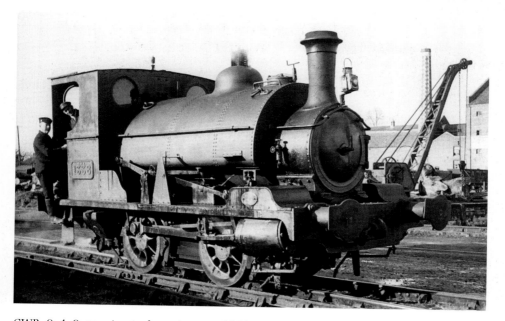

GWR 0–4–0 pannier tank engine no. 1338, ex-Cardiff Railway, shunting alongside the Bridgwater docks in 1947. Railway lines surrounded the edge of the dock to Randle's timber yard, Bowering's Animal Feeds and Sully's coal yards. In the background can be seen the hand-operated crane used for loading and offloading vessels. The base plate to this crane is still in position at the western end of the inner basin.

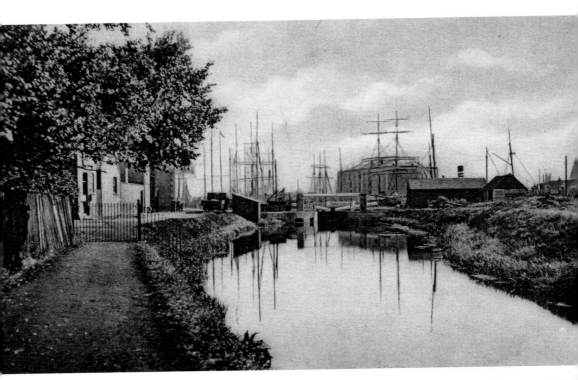

The masts of many ships moored in the Bridgwater docks reflect beautifully in the still waters of the canal at Newton Lock. The buildings to the left were erected in 1869, subsequently belonged to British Oil and Cake Mills, and were later owned by Bowering's. On the extreme right is the 110ft high kiln known as the 'Glass Cone' or the 'Glass House', originally used for firing glass but later converted for pottery. Built in 1771 by James Brydges, first Duke of Chandos, it was demolished in 1943 to provide the necessary hardcore for local airfields in wartime. The kiln base remained and has been preserved as an important example of industrial history. The 2-mile section of the Bridgwater to Taunton Canal from Huntworth to the floating harbour was not completed until 1841 to coincide with the opening of Bridgwater docks. Records show only twenty-three barges using the canal between 1905 and 1912; these carried sand, timber, coal and bricks.

he horse and cart of 'Gramp' Warren, pictured in the brickyard of H.J. Major & Co. Ltd in Colley Lane, ridgwater.

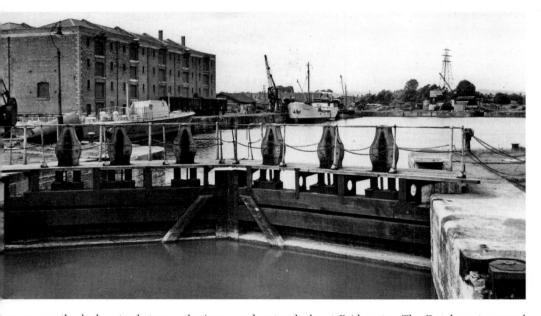

ere we see the lock gates between the inner and outer docks at Bridgwater. The Dutch motor vessel *turnus* is discharging her cargo of 45-gallon drums of dried milk powder from Dublin. The author members spending many occasions after the war with the crew of the *Saturnus*, who provided ovisions during the austere years of rationing. On the left is the converted gunboat *325 Eidolon*, a 'C' ass 110ft long Fairmile. She was bought in 1947 by Peter Brett of Bridgwater and used as a home til he sold her in 1954.

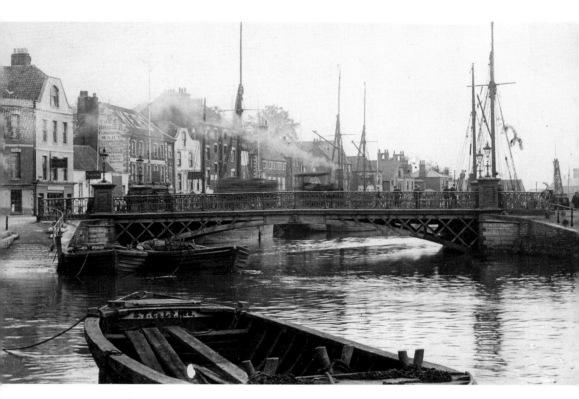

A view along the river to the bridge and double-ended Parrett barges (flatners) alongside
Binford Place. The barges would carry anything up to 14,000 bricks, or 20 tons in weight,
upriver towards Langport, often propelled by the long oar, or sweep. Alongside East and
West Quays a number of sailing ships are shown moored – a familiar sight in those days.
The barge in the foreground has the initials S.T. Co. Ltd. No 2, indicating that it belonged
to the Somerset Trading Company. The slipway to the stern of the barge was built in 1488
and known as 'Langport Slip' or 'New Slip'. Because of the restrictions of the Town Bridge,
goods were trans-shipped here in order to continue their journey upriver by barge. Bath
bricks, believed to have been named after their resemblance in colour to Bath stone, were first
manufactured locally in about 1823 from the slime or silt that had accumulated within the
2-mile length of the banks of the river between Somerset Bridge and Castle Fields. Companies
sprang up to take advantage of the growing trade, and names like Barhams, Colthurst
Symons, Parrett Bath Brick and John Board became part of the local scene. Slime dug from
the River Parrett at low tide was mixed in a mill, rolled (called 'obstricking') and placed in
rectangular moulds, then tapped out and placed on pallets (known as hacks) for drying.
Once dry, the bricks were put into an up-draught bottle-shaped kiln. After a short time they
were wrapped for sale locally and for export to Europe, the Middle East, America and China.
Millions were made annually and were used for cleaning and scouring. By the start of the
Second World War the industry had almost ceased as alternative cleaning methods became
more popular.

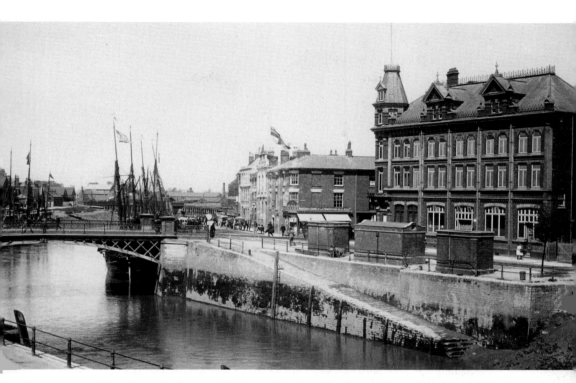

The junction of East Quay, Eastover and Salmon Parade, Bridgwater, dominated by the YMCA building on the corner. Constructed on the site of the old Globe Hotel in 1887 and known as the George Williams Memorial Building, it was demolished in 1968 to make way for modern shop development. The square buildings situated on the quayside were built in 1868 and were toilet blocks. Moored nearest to the bridge is the trow *Norah*, owned by William Webb of Dunball and captained by William Britton of Bridgwater.

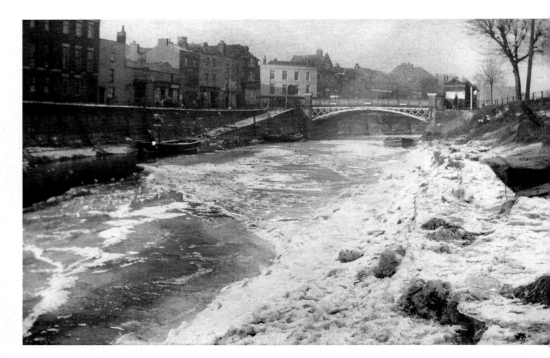

The River Parrett was well known for the hazards presented to shipping by the effects of harsh winter as these pictures clearly show. Dangerous ice floes were common, and in some years the river froze over completely. Some of the most severe winters over the last 150 years have been 1870, 1880, 1887, 189 1907, 1917, 1933, 1940, 1947 and 1963.

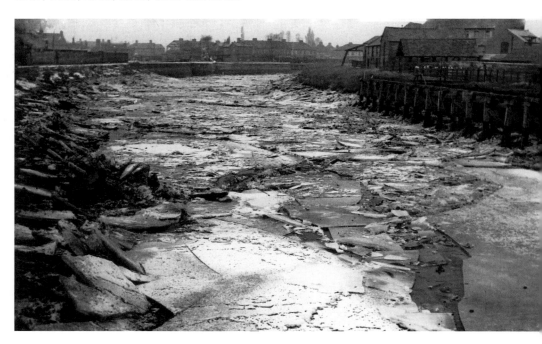

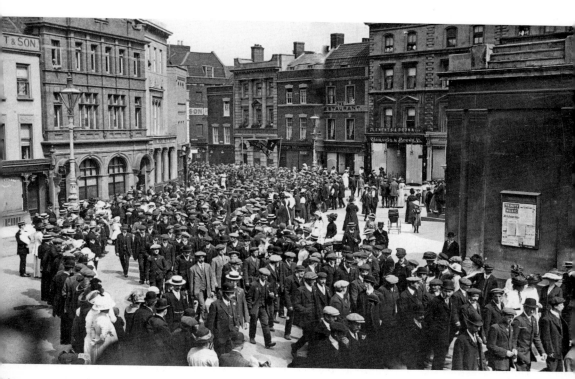

The 1913 labour demonstration on Saturday 22 June brought men and women on to the streets of Bridgwater in a show of strength and protest. Organised by the Bridgwater branch of the National Union of Railwaymen, whose membership was 230, the procession included hundreds of dockers, shipwrights, tailors, insurance agents, shop assistants and members of the Co-operative movement. As the procession moved off from St John Street its numbers swelled to over 2,000 when it was joined by other union branches from Highbridge and Bath. Carrying banners displaying the words 'Success to our Cause', the protestors made their way to the Town Hall for one of the largest labour meetings in the area. Speaker after speaker echoed the causes of labour unrest which, to the anger of owners and managers, was resulting in loss of production.

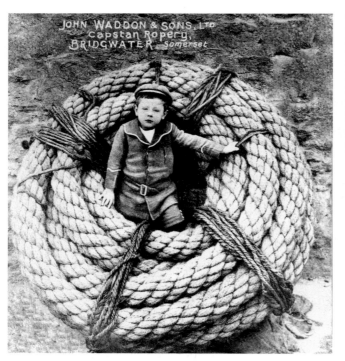

This fine advertising postcard of John Waddon & Sons Ltd of Eastover, Bridgwater, shows a typical massive core hawser, 2ft in circumference. Known as 'junks', they were specially made by Waddon's for Watchet harbour, where they were used by the hobblers to moor the large steamers. The former site of these premises is now named Rope Walk.

Overlooking the River Parrett at West Quay, Bridgwater, is this Norman watergate, the remains of the ancient Castle of Bridgwater originally built during the reign of King John in the thirteenth century by William de Briwere. It was destroyed by Fairfax and Cromwell after the siege in the seventeenth century.

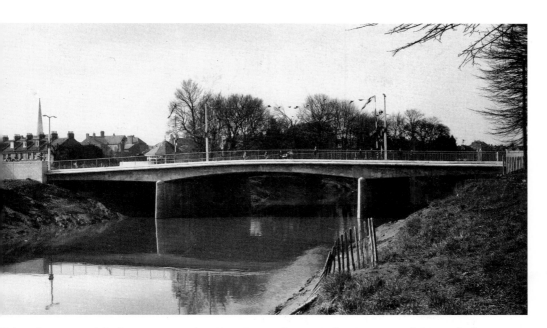

With only one road bridge spanning the River Parrett between the estuary and Burrowbridge, it was inevitable that the Town Bridge at Bridgwater would become a bottleneck for traffic as the number of vehicles on the roads increased. On 29 March 1958 the long-awaited internal bypass, known as Broadway, was opened with a second road crossing of the river, Blake Bridge, as it was to be known, which had two 45ft side spans with a 70ft centre span constructed from reinforced concrete beams.

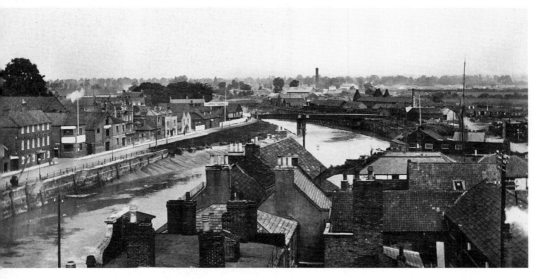

An unusual view from the top of the YMCA building, which stood on the corner of Eastover and Salmon Parade, looking over the rooftops of East Quay towards the drawbridge. It is a telescopic construction which took some fifteen months to build and was opened in 1871. To the right can be seen the masts of a ketch in the dry dock of Carver's Yard, with the brickyard kilns of Barhams in the distance.

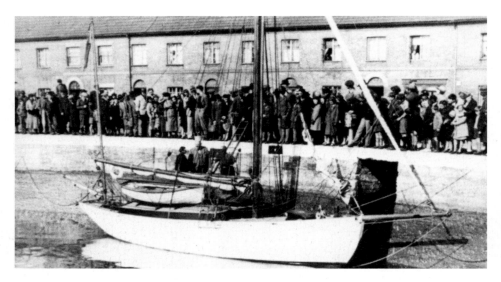

On Wednesday 21 April 1938 Commander Graham of Stawell, accompanied by his daughter, set sail from Bridgwater docks in his 11-ton sailing boat *Caplin* to cross the Atlantic. With an 8hp auxiliary motor, the 34ft craft sailed via the Azores, Bermuda and the West Indies, taking some twelve months to complete the passage. Crowds lining the dockside to wish them 'bon voyage' included Bridgwater's mayor, Councillor W. Chard.

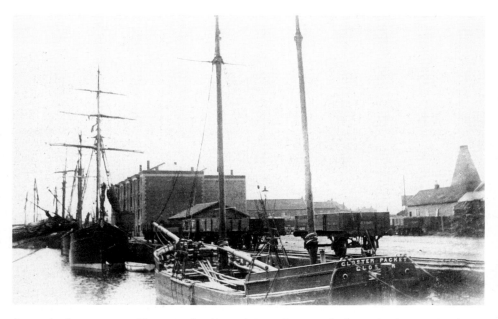

An early Severn trow *Gloster Packet* (Stroud, 1824) moored alongside the south side of Bridgwater's floating dock. The railway track which ran alongside the quay is clearly visible, together with the Chandos kiln on the premises of the Somerset Trading Company. Beyond the *Gloster Packet* is the schooner *Little Mystery*, built at Kingsbridge in 1887, which was destroyed off the Isle of Wight in June 1917 by enemy gunfire.

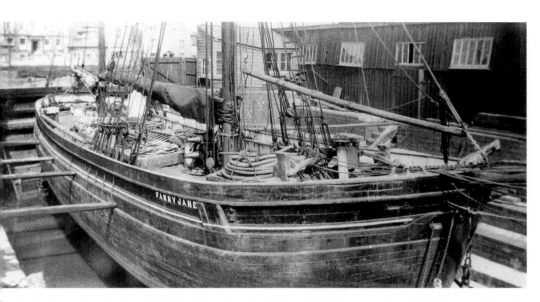

he ketch *Fanny Jane*, built in 1858 by John Gough of Crowpill, Bridgwater, firmly held by wooden poles
the dry dock of F.J. Carver at East Quay. On the right can be seen the gangplank providing access to
ne deck, the main and mizzen mast sails furled and coated, revealing the boom to the fore staysail, and
ne starboard bower anchor lowered to the dock floor, while the port anchor hangs at the hawsepipe. The
ock, built in about 1740 and last used in 1942, had stepped sides, the supports being used to retain the
essel in an upright position after the water level had drained back out into the river. Sadly no remains
this dry dock are visible today.

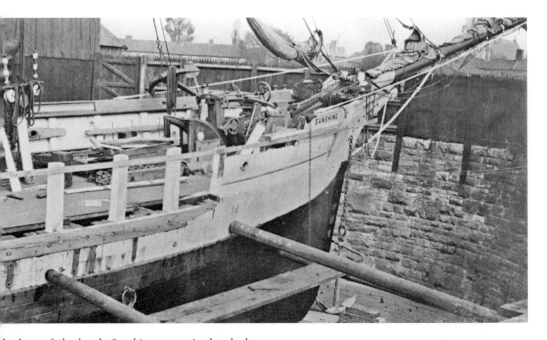

he bow of the ketch *Sunshine* secure in dry dock.

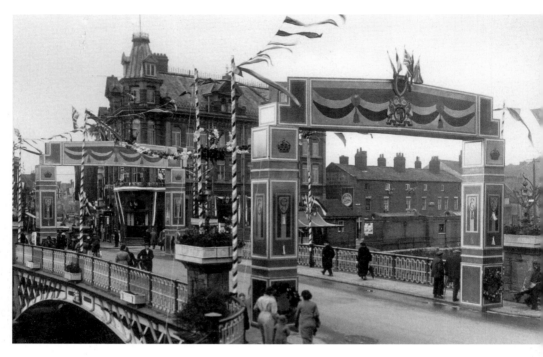

The Town Bridge decorations celebrating the coronation of King George VI on 12 May 1937 are reflected here in the wet road. A vast amount of time, effort and imagination went into the spectacular decoration that adorned the town.

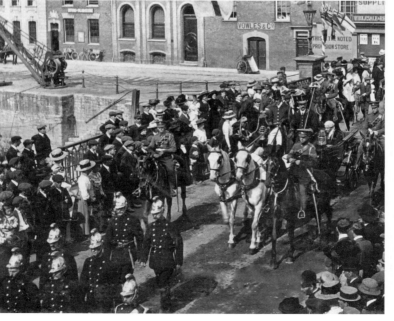

The annual July street procession in aid of Bridgwater Hospital Saturday Fund is seen here crossing Bridgwater's Town Bridge in 1910. Resplendent in gleaming livery, the carriages and well-groomed horses pull their VIP occupants, while local fire officers on foot add further colour. This charity event always attracted large crowds willing to hand over pennies to swell the funds for such a worthy cause in the days long before the National Health Service.

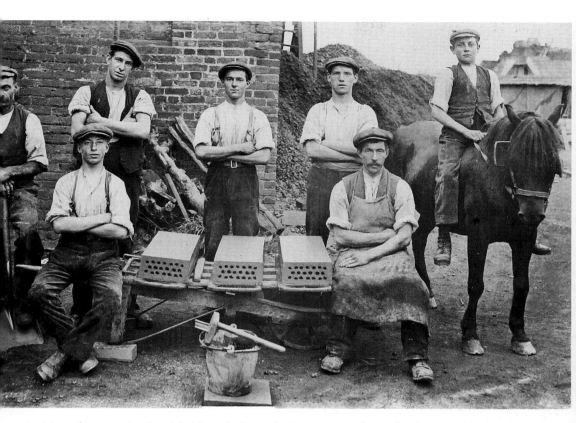

A picture for posterity. Local brick and tile workers pose with the tools of their trade, a scene familiar until the Bridgwater yards dwindled and died. Even in the days of the Roman occupation, clay was taken from the River Parrett for making pottery, but it was not until the nineteenth century that brick and tile production became commercially viable. From then until the First World War the process flourished, with companies, which included Colthurst Symons, Barham Bros, and John Board to name a few, making a very important contribution to the economic and industrial development of Bridgwater. By 1861, manufacture ran at 8 million bricks per annum, increasing to 17 million by 1900, most of which was exported. But, development of cheaper and more effective alternatives led to a trade downturn. Depletion of manpower and disruption of exports by the First World War added to the decline, and the industry finally was doomed by its inability to respond to the need for modern manufacturing processes and equipment. Use of the river and docks dwindled.

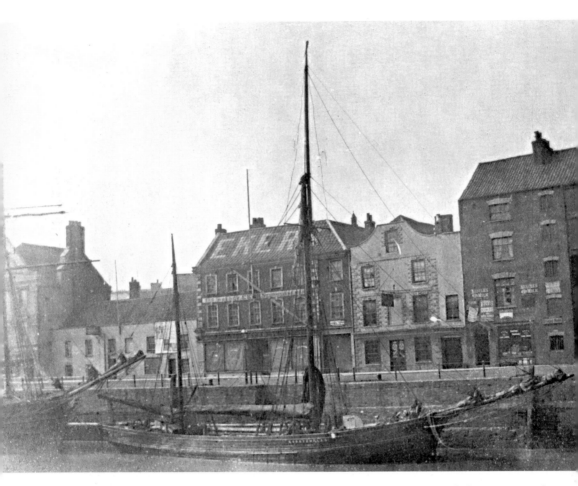

The low roofline of the Anchor public house and the furniture store of Ekers, next to the King's Arms public house at West Quay, provide the background for this view of the Sully & Co. ketch *Good Templar*. Built in 1881 at Goole and registered at Bridgwater in 1895, she foundered off the Welsh coast in November 1911, the mate losing his life. Laden with coal for the Bridgwater Gas Company, she lost her steering gear during a strong gale, her bulwarks were torn away, the vessel's small boat smashed and, finally, the mizzen sail was torn to ribbons. However, an approaching craft saw her distress signals, and a steam trawler from Fleetwood in the vicinity took off Captain Creemer of Bristol Road, Bridgwater, and the three remaining crew, the craft sinking stern first only a short while later.

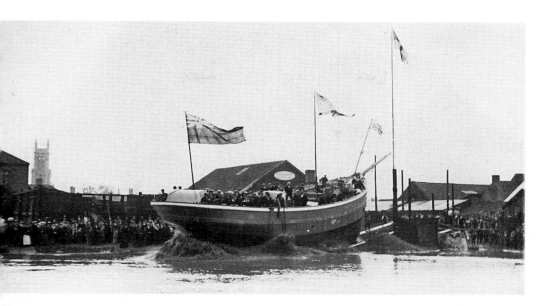

ednesday 5 June 1907 was a chilly morning for the launch of the *Irene* from the slipway of Messrs F.J.
rver & Sons' shipbuilding yard at East Quay, Bridgwater. With a length of 85ft, a breadth of 21ft, and
depth of 9ft, she was registered to carry 165 tons. Purchased by Clifford J. Symons of Taunton Road,
idgwater, Clifford Symons of Camden Road, Bridgwater, and her future skipper Captain William Lee,
e was used in general trade from the port. As she slid into the river, the *Irene* drifted across the water
be moored alongside the Bridgwater ketch *Sunshine*. Alongside East Quay she was fitted out with masts,
ging, crew quarters and so on, prior to her maiden voyage.

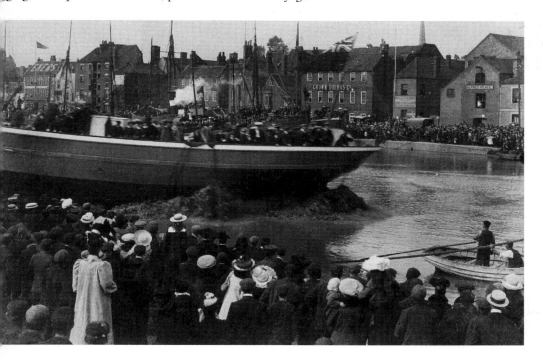

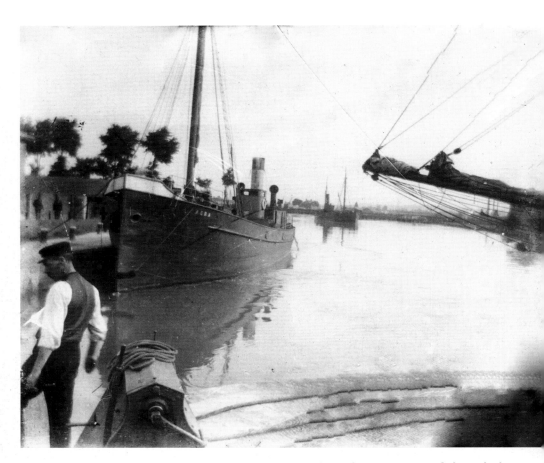

An artistic study of the steamship *Acra* alongside Saltlands as she is manoeuvred through the narro
entrance to Bridgwater docks. The bowsprit of another vessel is visible to the right, and a Sully's co
ship awaits her berthing on the high tide. This photograph, taken from a damaged glass plate, is wort
of inclusion, if only for its portrayal of the action necessary when a number of ships converged on t
docks at the same time. Sailing ships were winched by rope into the tidal basin using a pulley attach
to the dockside.

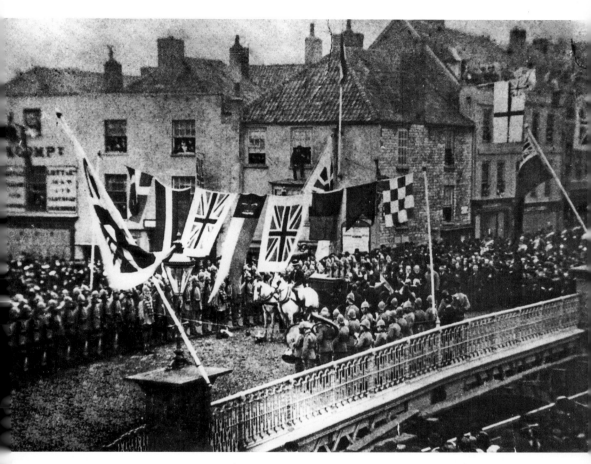

The present Town Bridge was officially opened on 5 November 1883, replacing an earlier structure which proved too steep and inadequate. In this photograph the mayoress, Mrs W.T. Holland, having been brought to the centre of the bridge in a horse-drawn carriage, is shown unlocking a padlock attached to a brass chain suspended across the bridge centre underneath the flags. As the National Anthem was played, the mayoress led a procession, which included the band of the Rifle Corps, across the new bridge. In the evening a fireworks display, followed by the Guy Fawkes Procession, took place. This was only the second official Bridgwater Guy Fawkes Procession ever, but now, well over a century later, the event surpasses itself annually.

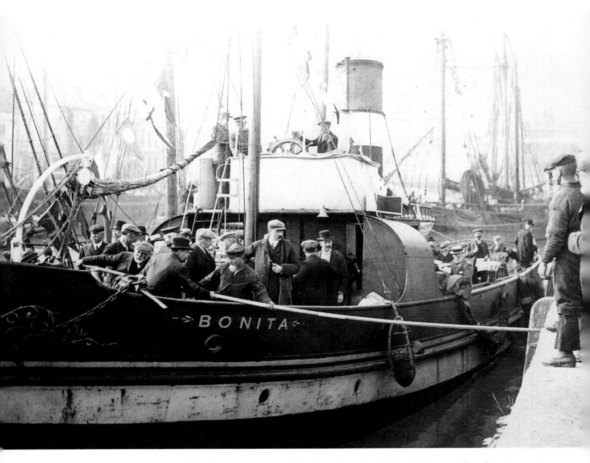

A civic inspection of the buoys, strategically placed in the Bristol Channel for shipping using the River Parrett, was carried out annually. Led by the mayor, members of the corporation, magistrates and borough officials would board the steam tug *Bonita* with Captain Smart in charge. Leaving West Quay, the 12-hour, 120-mile trip would take in Lynmouth, the Welsh coast and the Devon and Somerset coasts. Catering facilities were provided by Taylor's of High Street, Bridgwater. A large crowd of townsfolk would congregate on the quay to welcome home the intrepid sailors, whose return would be signalled by the firing of a cannon. Are civic outings as exciting today?

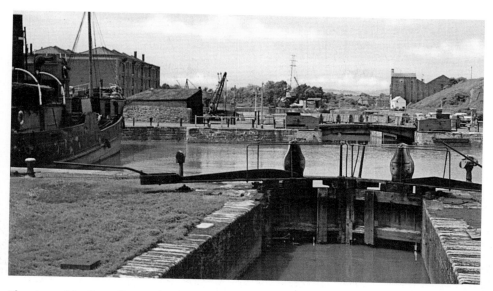

The steamship *Crowpill* discharging coal alongside Sully's wharf in Bridgwater docks. In the foreground is the barge lock, only opened in later years for the occasional motor boat or the flat barge used by divers for dock repairs. The docks now enjoy a new lease of life with the restoration and conversion of Ware's warehouse, the attractive apartment development and the reopening of the canal. The barge lock, now restored, is the main access for barges and other small craft entering the docks, now a marina, the days of the shipping trade having given way to leisure and pleasure pursuits.

Sully & Co.'s ketch *Parkend* was moored for some years at this berth in Bridgwater docks. Built in 1873 at Ipswich, and rigged as a brigantine, she was re-rigged later as a ketch, as shown here. Facing her is the iron steamship *Bulldog*, also owned by Sully & Co.

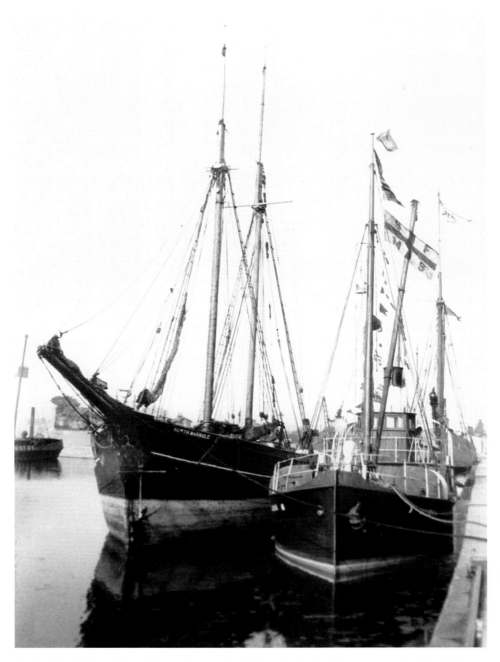

To the left of this picture is the schooner *North Barrule*, built at Ramsay on the Isle of Man in 1880 and named after a mountain called North Barrule just south of Ramsay. This was the earliest motorised cargo vessel to enter Bridgwater docks, her 21hp auxiliary engine having been fitted in 1909. On her inside is the steamship *Devonia*, dressed overall with flags flying at the main and mizzen mast, with the *Irene* just visible behind. This photograph was taken on the occasion of the Silver Jubilee of King George V on 6 May 1935.

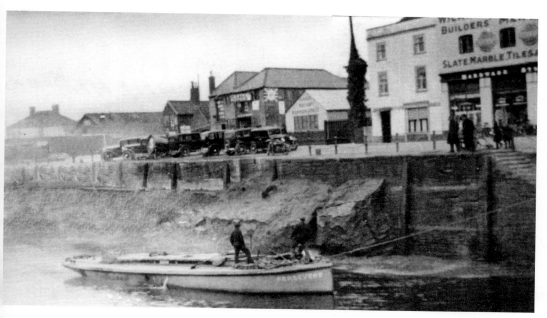

Built in 1932 for the Somerset Rivers Catchment Board, the 50ft long *Persevere* was known as a hydraulic erosion dredger. With a hull built by Charles Hill of Bristol, and pumps and jets designed and built by W. & F. Wills of Bridgwater, it used high-velocity water jets to disturb the silt along each side of the Parrett banks, which was then carried away by the flow of the tidal water to the open sea. It had two 75bhp three-cylinder Petter 'Atomic Diesel' marine engines, one for propulsion, the other for driving the six jets of the eroding plant, two of which pointed directly downwards while another two inclined downwards at an angle of 12 degrees from the horizontal. A further submerged jet swivelled at the bow and the remaining jet swivelled on the deck for trimming the banks.

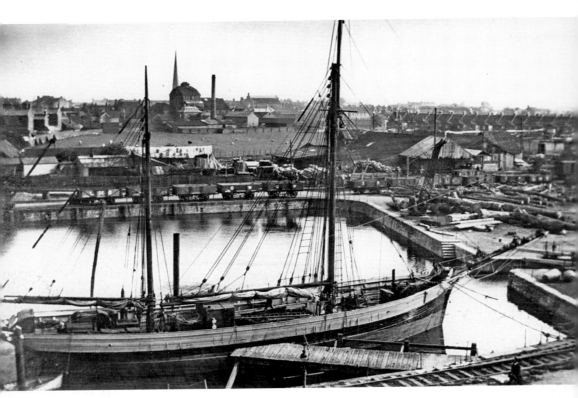

Looking across Bridgwater docks from the 'Mump' provides a superb view of the ketch *Sunshine* high in the water after unloading her cargo. Behind the railway trucks, to the right of this 1935 photograph, is the timber yard of George Randle & Son Ltd, and in the far distance is the spire of St Mary's Church with the brewery of Starkey, Knight & Ford Ltd at the back of the picture in the centre.

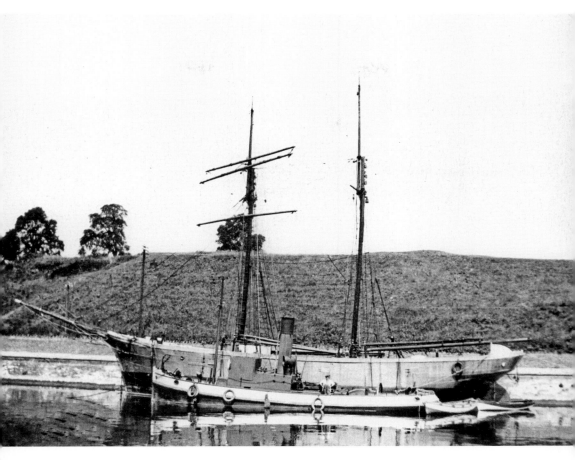

The 'Mump', created from spoil accumulated from the excavations of Bridgwater dock between 1837 and 1840, is the backdrop to this photograph taken in about 1930 of the steel topsail schooner *C. & F. Nurse* (named after Charles and Frank Nurse) owned and commanded by Captain Kelly of Nether Stowey. Both gaffs have been lowered to the main and mizzen boom ready for sailing. Alongside is the tugboat *Edward Batters*, built in 1908 at South Shields but not registered at Bridgwater until 1922. She was broken up in 1934.

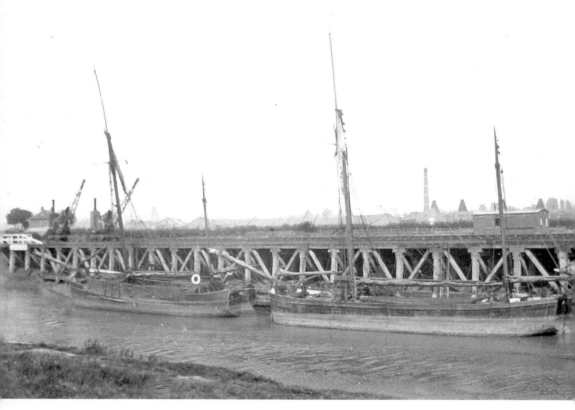

The full length of the Somerset & Dorset Railway wharf is shown in this photograph taken from Saltlands towards the east bank of the Parrett at Bridgwater. Several brick kilns, known locally as 'Pinnacle kilns', are visible in the distance. On the left is the 1827 Brimscombe-built trow *Palace*, which became the subject of a rescue in April 1916 when she got into difficulties off Sand Point, Kewstoke Bay, and three crew members and the ship's dog were rescued by the Weston-super-Mare lifeboat. To the right is the ketch *Stroud Packet*, built in 1823 also at Brimscombe (which is near Stroud in Gloucestershire). The trow with her side-cloths in position and the ketch with her hatch-covers fixed, suggests that these two vessels were taking the next tide, having discharged their coal cargoes for owners George Bryant and Sons, coal merchants of Bridgwater.

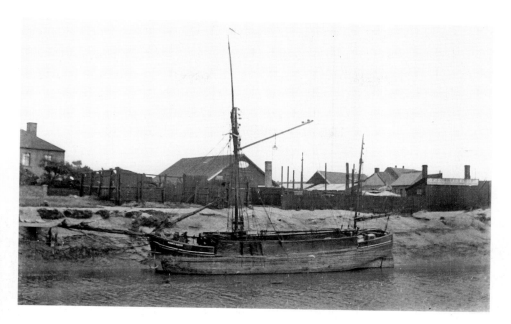

On 1 December 1909 George Sharman
was captain of the *Robin Hood* on a voyage
from Lydney to Bridgwater with a cargo
of coal when she went aground and sank
at the east point of the River Usk during
a raging gale. All on board were rescued
by the SS *Bulldog*, also from Bridgwater.
Built at Bristol in 1852, this 39-ton trow
is seen here alongside East Quay near the
premises of F.J. Carver. She had an open
hold, no hatches, and canvas side-cloths
(visible in position). Her mizzen boom
appears to have been pulled up several
feet to allow the crew to walk about at the
stern.

The converted steam tug *Parret* passing
through the moveable centre section of
the telescopic bridge in 1949. The first
boat through for some eleven years, the
Parret was built at Queensferry in 1915
but not registered at Bridgwater until
1929 and eventually broken up in 1959.
On this occasion the telescopic bridge
was manually withdrawn by an engineer
summoned from Taunton, as the steam
engine normally used to open the bridge
was no longer working after so many years
of inactivity.

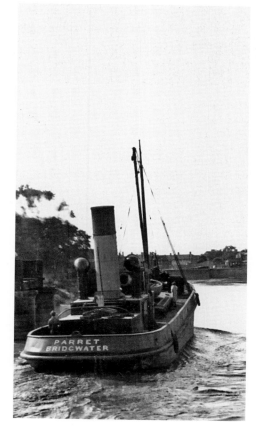

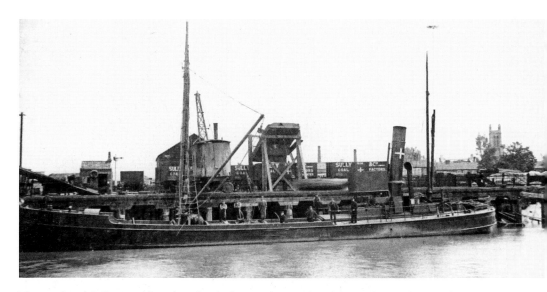

The trucks of Sully & Co. line the wharf of East Quay, Bridgwater, on the south side of the Bascule Bridge having been filled with coal brought from South Wales. Coal was discharged by hand into metal tubs offloaded by steam crane on to a wooden platform and from there went into the waiting coal wagons. The steamship *Welsh Prince* was built in 1871 by G.K. Stothert at Bristol but not registered at Bridgwater until 1904. Owned by Sully & Co., she was broken up in 1930.

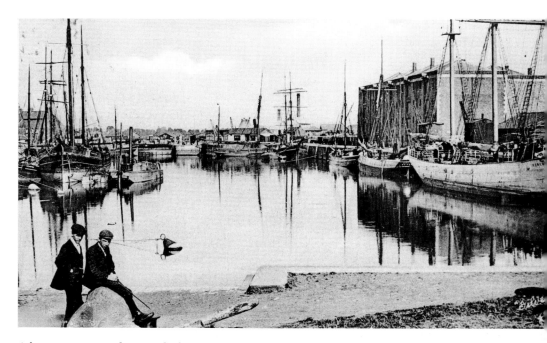

A busy scene at Bridgwater docks, although the two lads seem more interested in the cameraman. From the left are the ketch *Crowpill*, the ketch *Parkend*, the dock-scraper *Bertha*, the ketch *Marie Eugenie* and the three-masted topsail schooner *Circe*.

The rigging of a vessel alongside West Quay, Bridgwater, forms a frame for this view of the schooner *Lilla* moored opposite. Built in 1868 at Freckleton, the *Lilla*, of 55 tons, was registered at Bridgwater in 1894 and traded until bulked in 1928. In the background is the YMCA building. The hand-operated crane for loading and unloading ships remains to this day on the redeveloped East Quay.

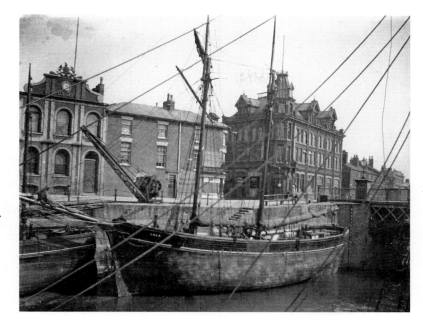

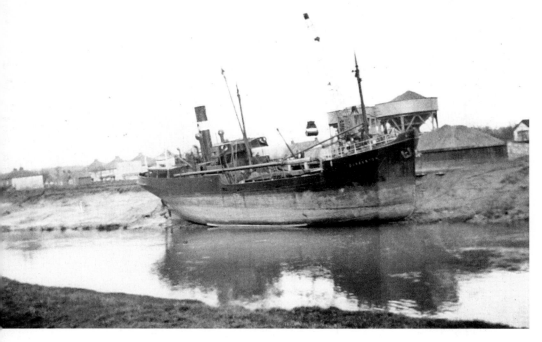

This pre-war sand dredger *Dunkerton*, belonging to the Bristol Sand & Gravel Company, is pictured alongside the firm's wharf beside the main A38 Bristol Road in Bridgwater just visible in the background. The land for this wharf was purchased in May 1935 to facilitate the unloading of materials connected with the construction of the British Cellophane factory in Bath Road, Bridgwater. To the left of this picture was the author's house, from where, during his childhood, he spent hours watching the boats coming up and down the Parrett and the discharging of sand and gravel at this wharf.

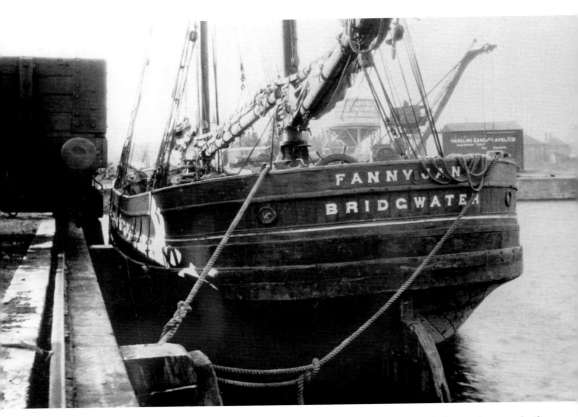

A photograph illustrating clearly the timber planking of the stern of the Bridgwater-built ketch *Fanny Jane*, moored alongside railway wagons on the south side of the inner dock at Bridgwater. Railway lines ran along three sides of the floating dock, with small turntables enabling railway trucks to be turned by 90 degrees so as to serve each side of the dock for loading and unloading purposes. In the background is the hopper of the Holms Sand & Gravel Co., where the sand dredgers of that company discharged their sand and gravel.

obert Blake was born in 1598 in a stone
roperty in Blake Street, formerly St Mary
treet, Bridgwater, and now the Blake
Iuseum. The oldest of the fourteen children
f Humphrey Blake, an export merchant of
ubstance, grandson and son of local mayors
f Bridgwater, he spent the first sixteen
ears of his life at home adjacent to the
iver Parrett and Durleigh Brook and within
ght of the old stone bridge. Following some
ine years at Oxford, he returned to the
rea, living at Knowle Manor, Puriton (now
emolished), overlooking Downend Pylle and
he loop in the River Parrett. This loop existed
ntil 1678 when Sir John Moulton completed
is plan to straighten the river at Viking's
ill on Horsey Level, thereby reclaiming some
50 acres of land and easing the difficulties
f wind-assisted sailing ships in navigating to
ridgwater. The naval and historical successes
f Robert Blake have been documented at
ength elsewhere, and brief reference here to
his hero and son of Bridgwater is but a mark
f respect and regard for the town's most
amous man.

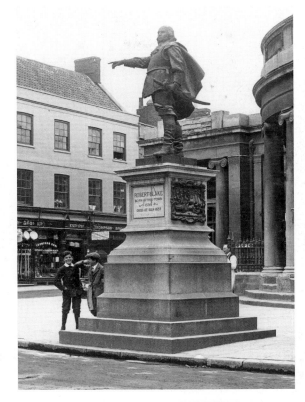

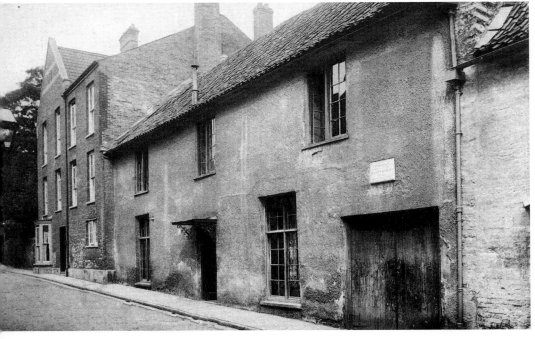

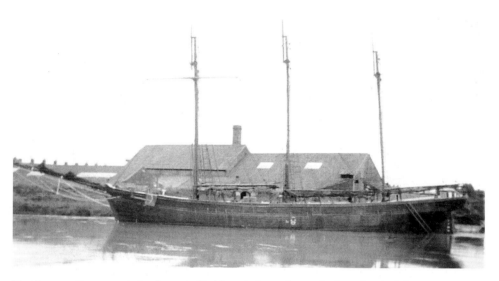

The famous three-masted schooner *Kathleen & May* alongside the wharf of the Parrett Bath Brick Company, built in 1900 at Connah's Quay, Flintshire, by Ferguson & Baird. The Bristol Road premises of the Parrett Bath Brick Company concentrated on the production of Bath bricks from 1886 and continued right up to the outbreak of the Second World War. Restored at considerable expense, she has been sighted by the author on a number of occasions recently along the West Country coastline. To the left are the chimney-pots of Parrett Buildings alongside the A38 into Bridgwater.

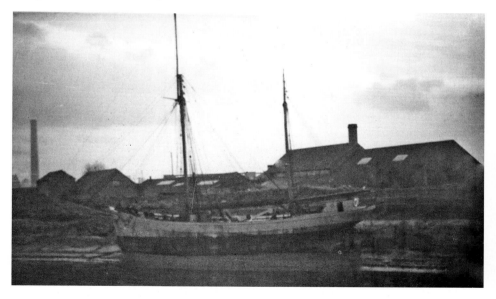

Bridgwater's *Irene* alongside the Bristol Road premises of the Parrett Bath Brick Company. To the left of the bowsprit is what was then the newly constructed chimney of British Cellophane, later known as Courtaulds, which closed down in 2008. By virtue of the longevity and restoration as a historical sailing ship, the *Irene* may have acquired an importance her builders and subsequent owners could not have imagined.

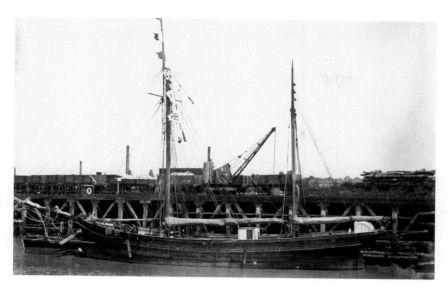

Between the masts of the *Irene* can be seen the steam crane built by Thomas Smith of Rodley, near Leeds. The crane ran on broad gauge track along the 400ft wharf of the Somerset & Dorset Joint Railway on the east bank of the River Parrett at Bridgwater. Staging below the bowsprit suggests that the *Irene* was undergoing the final painting of her hull after being fitted out with masts, rigging and crew quarters, following her launch on 5 June 1907. The flags decorating her mainmast may have heralded her maiden voyage.

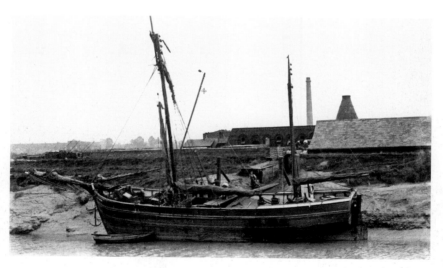

The brickyard of Colthurst Symons provides the backcloth for this photograph of the ketch *Two Brothers*, built originally as a trow by John Gough of Bridgwater and broken up in 1922. Bath bricks were produced by Colthurst Symons on the Bristol Road site from about 1861 and advertised as late as 1939, although by then the demise of the industry was imminent, the competition from alternative cleaning agents proving too great.

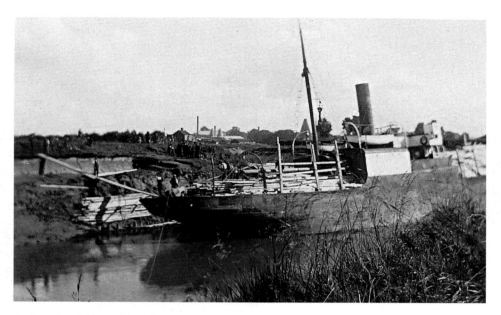

On Tuesday 28 June 1927 the German steamship *Masuren*, bringing a cargo of 500–600 tons of timber for the Somerset Trading Company, ran aground on the western bank at Saltlands on a 2ft ebb tide. Listing heavily to port, she straddled the river, keeling over and finally capsizing on her side with her funnel practically parallel with the water, the pilot and crew escaping along the mast to the eastern bank. As she filled with water her cargo was thrown overboard and floated upstream. Eventually her deck cargo was removed and with the holds pumped out, the incoming tide righted her so that she could be safely moored on the west bank.

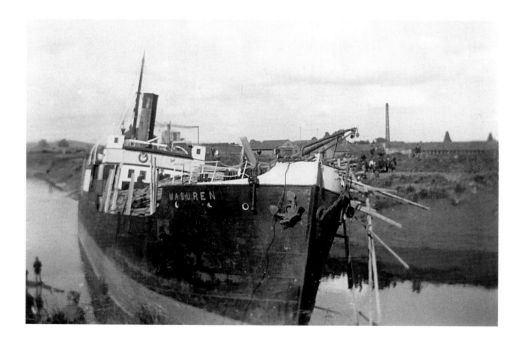

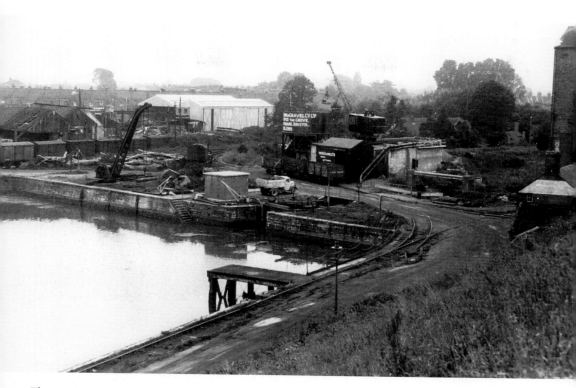

The western end of the docks, with the premises of Holms Sand & Gravel Co. Ltd and the timber yard of Geo. Randle & Son Ltd to the left. Sand dredgers using suction pumps brought up 'Bristol Channel' grit, 'Holms' sand and 'Bideford' gravel from the bed of the Bristol Channel, which was then unloaded at this wharf by crane into hoppers before being distributed by road transport.

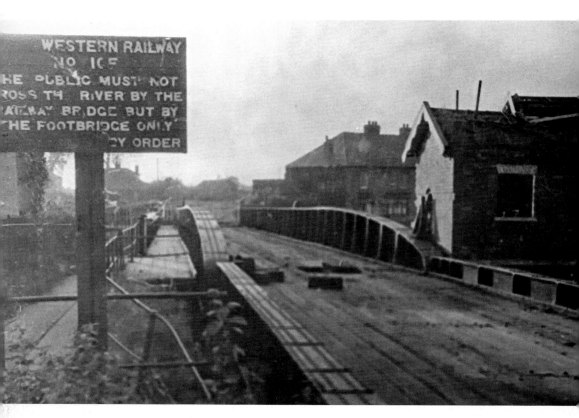

The old iron single-track rail bridge seen here in about 1969 in a rather sad state of disrepair, the steam engine in the machine house to the right having been removed by British Railways in the early 1960s. The heavy wooden planking was removed in 1982 when the bridge was converted for road traffic use. Completed in March 1871, the telescopic bridge, or 'black bridge' as it was known locally, consisted of three sections. A cog mechanism in the engine house, powered by a steam engine with a vertical boiler, pulled the traverser section sideways into the traverser pit. This allowed the balanced middle section of the bridge to be rolled back by the chains, attached halfway along the underside of this section, into the area vacated by the traverser. The third section of the bridge was fixed between the west bank and supporting pillars in the river. In the event of engine failure it was possible for the bridge to be opened and closed by manually operated winches. On the brickwork, some 3ft higher than the river bank, was a flood mark dated 1883.

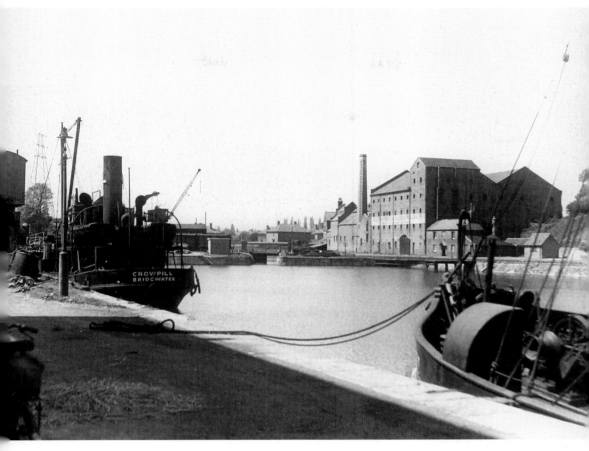

The bows of the Sully-owned steamships *Parret* and *Crowpill*, easily distinguished by the white upright cross upon a black background on their funnels. Across the docks are the premises of the British Oil and Cake Mills, later to become Bowering's, manufacturers of animal feeds, and a familiar landmark to this day. On the left is one of the two steam cranes which travelled on standard gauge track along the south side of the floating dock.

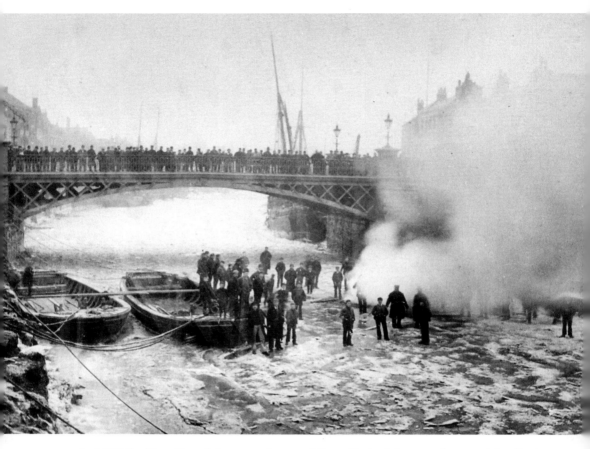

In 1895 the River Parrett froze over in one of the coldest winters ever known. A bonfire has been lit on the ice, while crowds of onlookers watch from the bridge. Photographs of this unusual sight were in great demand, and sold quickly as local people sought a permanent record of such an unusual event.

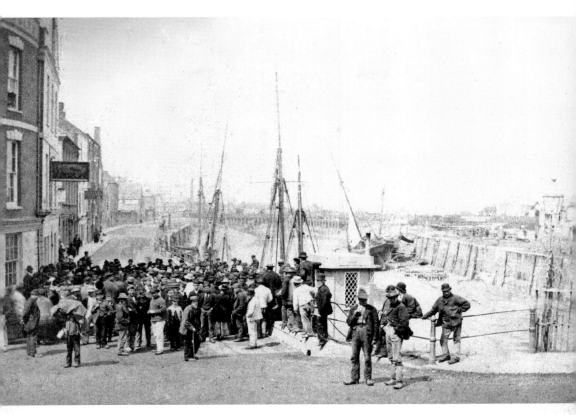

This early view is believed to show 'hobblers' congregating at West Quay. Hobblers were casual workers from the area, taken on when ships were mooring or casting off, and who did the routine but hard work of lowering or hoisting sails, securing, releasing and storing mooring ropes and raising and lowering anchors to winch the vessel alongside the berth, a procedure known as 'warping' or 'tracking'. Competition between the men for work was fierce, and they would hang around all day hoping for employment. Payment to a hobbler was based upon the tonnage of the vessel and its country of origin, the heavier the tonnage, the harder and longer the job, so the more a man was paid. Some owners were prepared to pay an extra amount for a speedier job. The lamp to the right was situated at the approach to the narrow and steep old Town Bridge which was demolished in 1883.

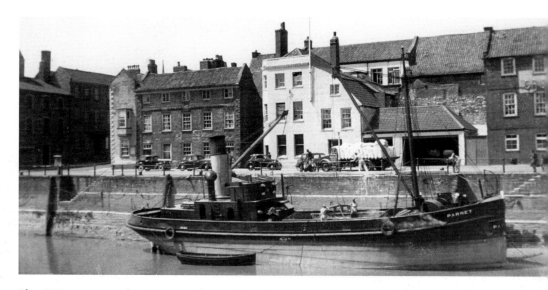

The 120-ton steamship *Parret* tied up alongside the premises of Messrs Peace Ltd. at West Quay Bridgwater, 1949. Her own steam-driven derrick was used for unloading sacks of flour on to a waiting lorry. The hatch beams are shown being inserted into position before the covers were fitted prior to sailing. This proved to be a historic photograph, since it shows the last ship ever moored alongside either East or West Quay with cargo. The *Parret* was broken up in 1959.

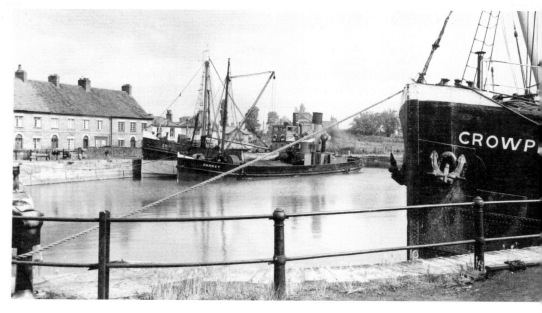

Many local people will remember the three faithful steamships owned by Sully & Co. which plied their trade up and down the River Parrett, and which are shown here moored in the small tidal basin at Bridgwater. In the foreground is the *Crowpill*, built at South Shields in 1911 and broken up in 1966, then the *Parret*, built at Queensferry in 1915 and broken up in 1959, and on her inside *Enid*, built at Maryhill, Lanark, and also broken up in 1959.

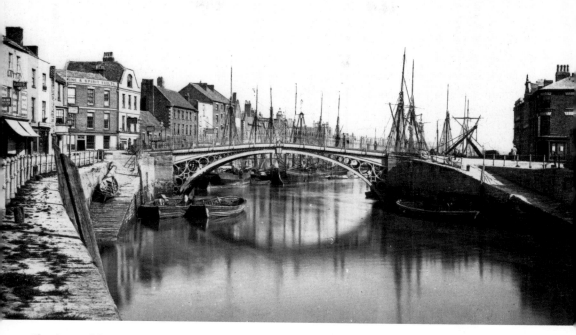

The beautiful 1795 iron bridge with a 75ft span, which replaced the medieval Town Bridge and to which was affixed a plaque bearing the name of Robert Codrington, mayor of Bridgwater in that year. Cast by the Coalbrookdale Company of Shropshire at a cost of £4,000, the iron span was brought to Bridgwater by trow via the River Severn. The increase in horse-drawn traffic, which had to take the steep incline each side of the old bridge at slow speed and with extreme care, caused traffic problems and the need for a replacement bridge had become urgent.

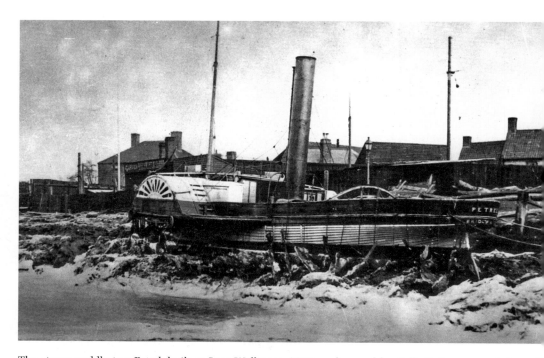

The steam paddle-tug *Petrel*, built at Low Walker in 1863 and owned by Sully & Co., moored alongside the premises of Carver & Sons, shipbuilders of East Quay, Bridgwater. These paddle-tugs were used to tow several sailing vessels roped together in line, to and from the mouth of the Parrett Estuary as high tide approached.

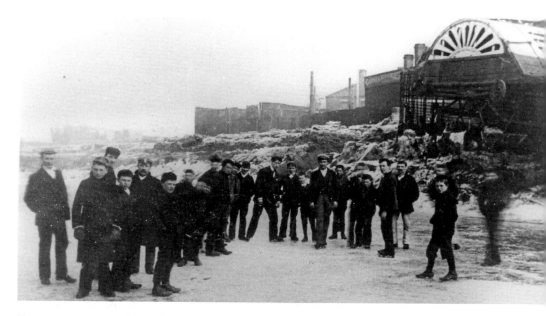

Young men pose on the ice beneath the paddle wheel of the *Petrel* during the hard winter of 1880.

Mr William Pocock at Valetta Place, Bridgwater, with his salmon net and two fine specimens of locally caught fish. The net comprised an ash pole called a 'spill', some 10ft long, with two curved willow stays of about 4½ft, divided by a two-holed yoke fixed to the spill, covered in net with a 2-inch mesh. It was illegal for salmon to be taken from the river with a net between the hours of 6.00 a.m. on Saturday and 6.00 a.m. on Monday, unless a rod or salmon butt was used. The butt was a basket made from local withies laid in rows on the muddy bank and was the favoured form of salmon fishing towards the mouth of the river.

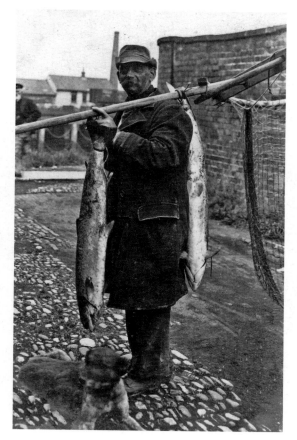

In 1874 a gridiron, a 162ft long heavy timber construction, was set down alongside East Quay to enable vessels to be serviced, maintained or repaired. The ketch *Galley* rests upon the timbers alongside the premises of F.J. Carver & Son Ltd at low tide, with the stern of Sully & Co.'s steamship *Welsh Prince* visible to the right.

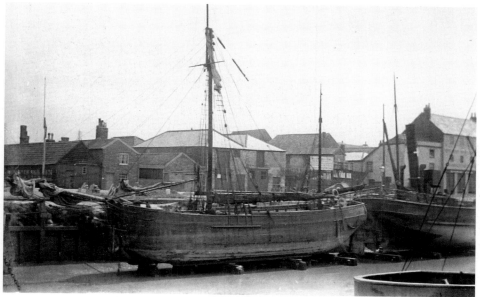

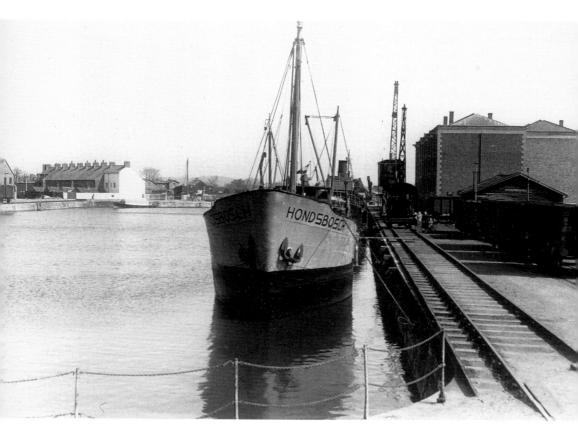

A foreign motor vessel discharging her cargo directly into trucks on the quay, alongside Ware's Warehouse.

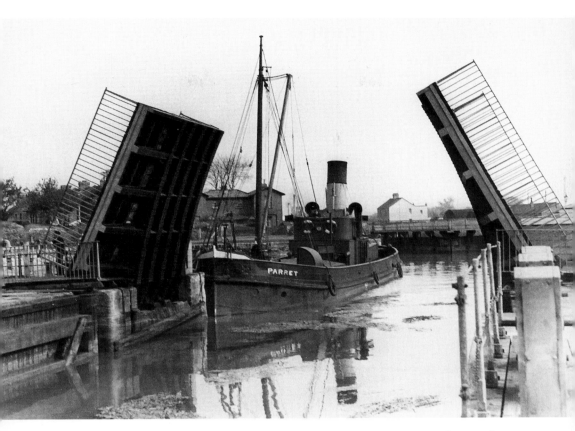

The unique double-leaf Bascule Bridge being opened manually to allow the Sully-owned steamship *Parret* passage to the inner basin in order to discharge her cargo at Bridgwater docks in 1952. In 1977 this bridge was closed to vehicles and a temporary structure was built for traffic going to Chilton Trinity. In 1981 the bridge was removed and a specialist Derby company restored the structure to its original condition. In 1983 each 30-ton section was reinstalled on its bearings and the winding-gear was connected up.

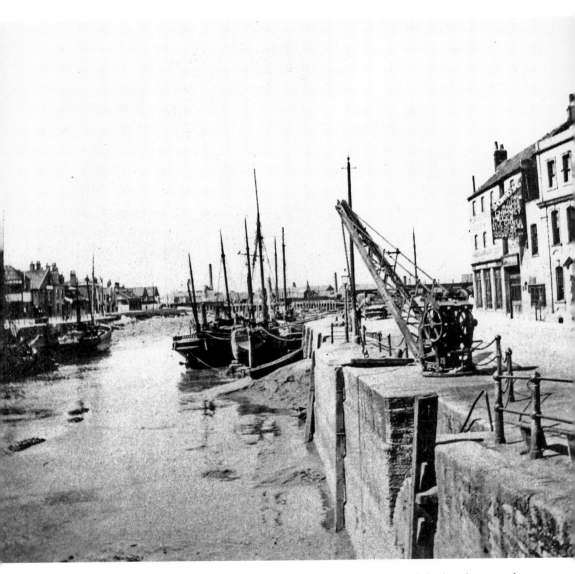

Shipping moored alongside both East and West Quays, the hook of the hand-operated crane used for loading and unloading vessels securely held by a fixed ring in the quayside. To the right is Wilkinson and Leng's hardware store and builders' merchants. The property next door was the post office until 1870, when this was transferred to High Street, before being moved to the Cornhill in 1909.

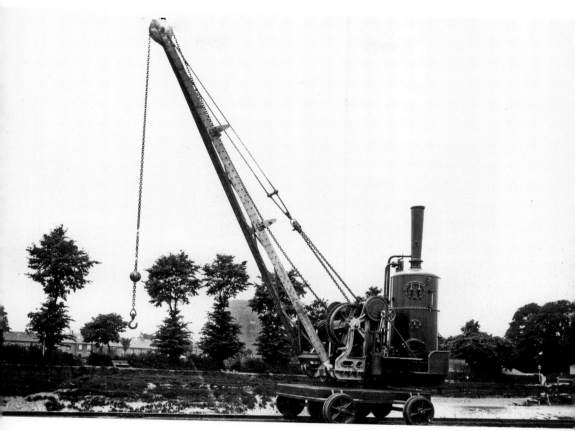

This travelling steam crane, built by Thomas Smith of Leeds, moved on broad gauge track along the 255ft timber wharf of the Somerset & Dorset Joint Railway landing stage, situated between Barhams' brickyard and Colthurst Symons' premises on the east bank of the River Parrett at Bridgwater. In 1912 the wooden structure became so dilapidated that the area was fenced off and by 1920 the crane had been transferred under its own steam to Highbridge wharf, where it continued its life loading and unloading ships belonging to the S&DJR. The crane driver had no overhead protection and had to endure whatever weather conditions prevailed.

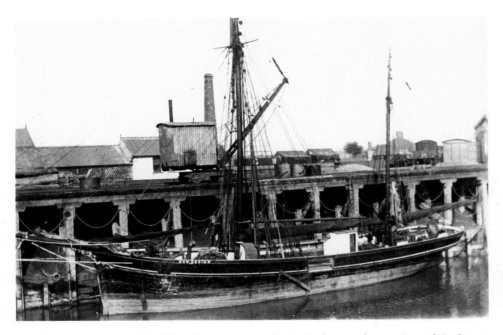

The unladen Bridgwater-built ketch *New Design* alongside the wooden staging of Barhams, East Quay, Bridgwater. A mobile steam crane with galvanised weather protection stands by to load bricks and tiles. Little of this staging is now visible as time and tide have taken their toll on the timber construction. The several buckets on the quay in front of the crane suggest coal was unloaded, although they may have been used to discharge sand, stone or lime. In her later years the ketch was laid up at Bristol Bridge and finally hulked in 1951.

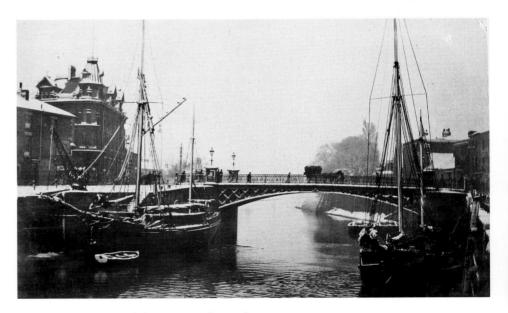

A bleak winter view of the Town Bridge and river.

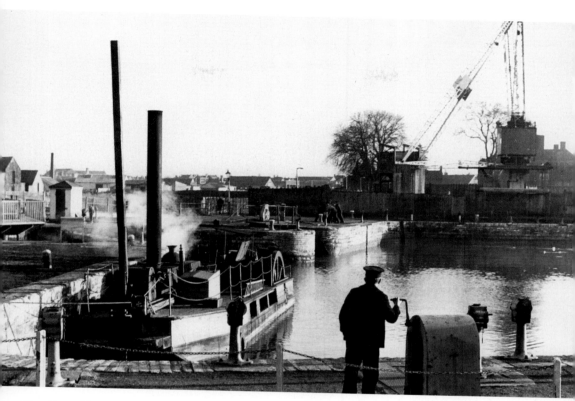

The Great Western Railway's steam-powered iron dredger *Bertha*, believed to have been designed by Isambard Kingdom Brunel in 1844 and still working in 1964 as the then oldest operating steam craft in the country, and possibly the world. Designed for clearing mud from the Bridgwater dock and 49ft 3in long, she pulled herself backwards and forwards across the dock on chains attached to the walls of the quayside. A large blade beneath the boat scraped and stirred the mud and silt, which was then sluiced from the basin into the river. The boiler needed many shovels of coal to build up enough steam for the pistons to produce the necessary 40lb psi pressure. As much as half a ton of coal would be consumed in a full working day. Presented to Exeter Maritime Museum by British Rail, she was a star attraction until she was moved in 1997 when that museum closed, and has been undergoing restoration in her new home at World of Boats, in the east Berwickshire fishing port of Eyemouth on the east coast of Scotland, just north of the border, as part of the National Heritage list of Historic Ships. At least part of the history of Bridgwater docks lives on!

Employees of F.J. Carver & Son Ltd pose proudly for the camera of L. Slocombe while standing on the newly completed lock gate for the Clyce at Highbridge. On the reverse of this photographic postcard taken in 1926, Albert Paice wrote that the gates 'took an average 3–4 weeks each to build. Each gate went in with absolutely no trouble without the least bit of trimming off the mitres' and he identified, from left to right; A.G. Attwell (manager), J. Trunks (yard handyman), B. Brightwell, A.E. Paice (blacksmith), C. Lewis (shipwright), W. Shakespear (shipwright), A. Paice (junior shipwright), S. King (shipwright) and W.J. Blackmore (shipwright).

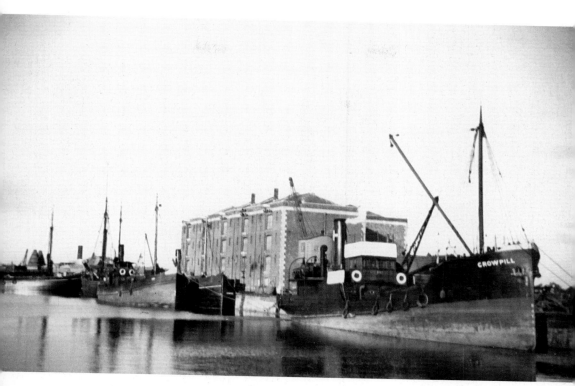

The Sully & Co. steamship *Crowpill* sitting high in the water with an empty hold at Bridgwater docks in 1938. Built in 1911 at South Shields, she plied regularly with coal between Bridgwater and various South Wales ports during the period 1934 to 1966, when she was broken up. To her stern is the steamship *Enid*, built in 1903 at Maryhill, Lanark, and also owned by Sully & Co. between 1931 and 1959, when she too was broken up. On her inside is the wooden steamer *Tender*, built by John Gough of Crowpill, Bridgwater in 1874 and used by Sully & Co. throughout her lifetime. She also met the fate of the ship-breaking gangs in 1943. Just visible in the distance are the ketches *Sunshine* and *Trio*. In 1873 the Port of Bridgwater ranked fifth in England for importing coal and culm (coal dust).

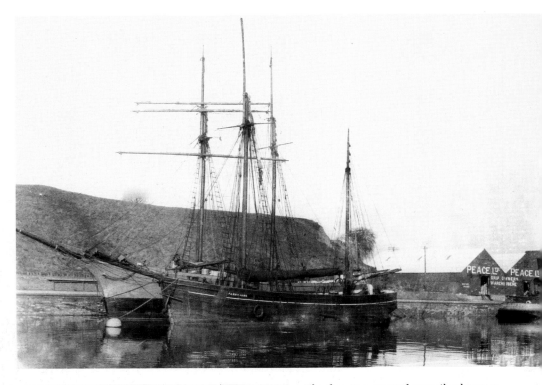

The fine two-masted topsail schooner *C. & F. Nurse*, built by Lean of Falmouth, moored alongside the starboard of the ketch *Fanny Jane*. The *C. & F. Nurse* sailed regularly between Bridgwater and the Mersey with Bath bricks, Runcorn and Fowey with coal, Fowey and London with china clay, and thence back to Bridgwater with cement. In about 1936 the hull was converted into a towing barge with the name *Enterprise*. Used on the Gloucester Canal until beached upriver at Sharpness in 1954/55 and cut down for scrap, the remains were covered by hardcore in 1971 when, with so many other old sailing vessels, she was used to strengthen the mud banks of the Severn to avoid erosion which threatened to break through to the busy canal.

Masts, spars and bowsprits laced with rigging. The 276-ton *Ausgar* of Marstal, built in 1893 is to the left, moored alongside the 200-ton *Cimbria* of Troeuse, built at Svendborg in 1903. How magnificent these ships must have looked alongside each other!

The 69-ton ketch *Ade* (formerly *Annie Christian*) slipping her moorings in the tidal basin before sailing to Glasgow in 1912. Built as a schooner in Barnstaple in 1881 by William Westacott, she was beautifully decorated with scroll work below her bowsprit, a well-known trademark of this Devon builder. In 1888 she was sunk in a collision, but was refloated and re-rigged as a ketch. During the First World War she was fitted with a gun and motorised. Surviving both hostilities and storms, she saw sixty-five years' service before being broken up in 1946. In the background is Russell Place, a terrace of seven cottages and two higher grade houses decorated with local tiles. Built for dock workers, these dwellings flooded frequently until improved drainage solved the problem.

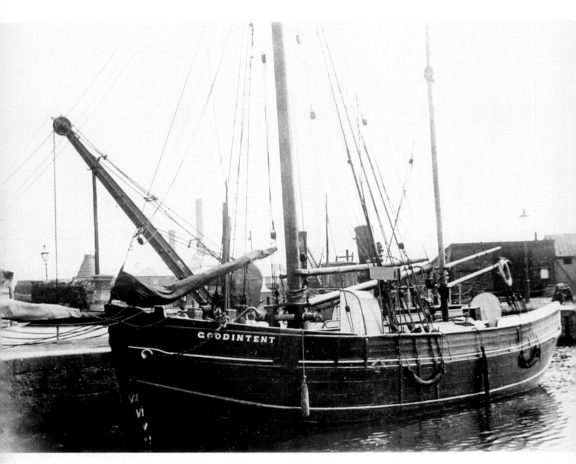

Built at Plymouth in 1790 from oak salvaged from an old British man-of-war of the George III period, the Bridgwater-registered ketch *Good Intent* is seen here alongside the quay at Bridgwater docks taking on cargo. In 1918 she was believed to be the oldest British merchant vessel afloat in the mercantile marine. In the ownership of the Smart family of Bridgwater for over fifty years, she often plied general goods between Bridgwater and Cardiff. In 1918 she was sold in Cardiff to Captain Bride for £385 and was scrapped at Pill in about 1927. On her stern and taffrail were the words 'The Sea is His and He made it'. In the background can be seen the dock smithy.

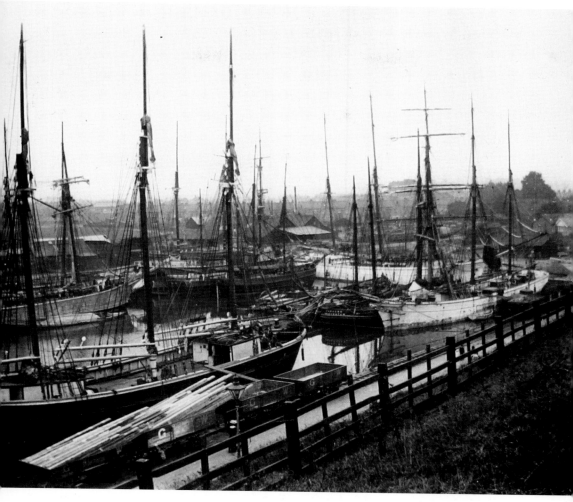

Nineteenth-century sailors said that at times it was possible to cross the 200ft width of the docks by walking over the decks of ships, so great were the numbers moored. While this picture does not show such a crossing as being possible, it does illustrate the extent of shipping when at its peak in the later part of the nineteenth century. Shown here are some twelve ships loading or unloading at the same time. They include the schooner *Sarah Jane*, the barque *Bertha* of Tomberg, Norway (built in Altona in 1865), the *Elbe* of Korpo, Finland (built in 1903), the *Maerdor*, the ketch *Industry*, the tug *Victor*, the schooner *Pique-au-Vent*, the *Arona* (built in Oskarshamn, Sweden, in 1904), the ketch *Parkend*, the *Aldebaran*, and the ketch *Crowpill* (ex-*John Wesley*), built in Harwich in 1873.

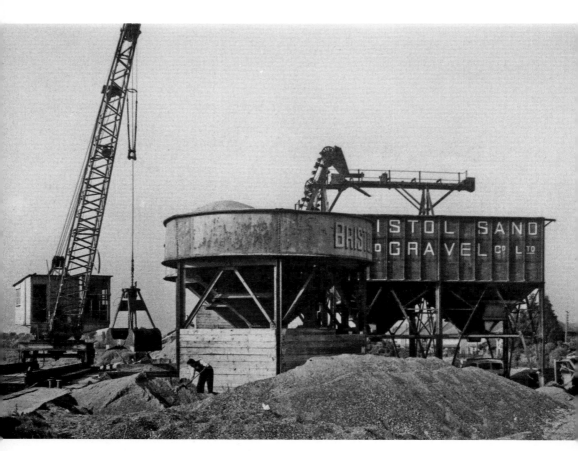

In 1935 excavations commenced for the construction of a new factory at Bath Road which was to be called British Cellophane, later a subsidiary of Courtaulds. Taking the initiative, the Bristol Sand and Gravel Company purchased riverside land to develop wharves alongside the A38 Bristol Road, so that building materials for the factory site could be brought upriver cheaply and easily. With the completion of the factory, the wharves were used to discharge sand and gravel sucked from the bed of the Bristol Channel by sand dredgers as described elsewhere. This photograph shows the electric discharging crane, sand hoppers and lorries being loaded with sand and gravel. The crane and hoppers are no more, but the wharf, with the rails of the mobile crane, remain.

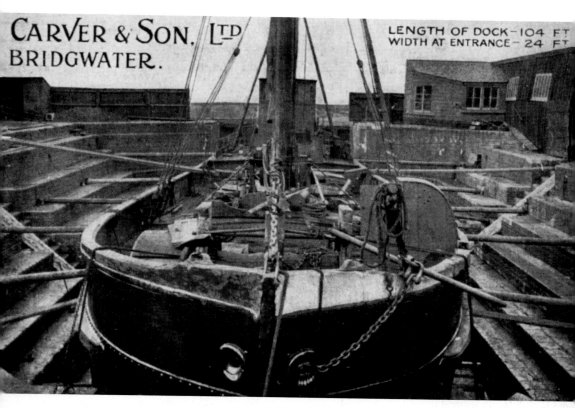

CARVER & SON, LTD
BRIDGWATER.

LENGTH OF DOCK - 104 FT
WIDTH AT ENTRANCE - 24 FT

Francis James Carver was the head of the shipbuilding firm F.J. Carver & Son. Born in Chilton Trinity in 1836, he was apprenticed at John Gough's shipbuilding yard, then located on the west side of the Parrett just below the docks. After rising to foreman, he started his own shipbuilding business on East Quay in about 1878, assisted by his son Frank who continued the business until his death in 1921. The company built many vessels in Bridgwater and its designs were much respected by Bristol Channel ship owners. His second son Harry was the managing director of the Bridgwater Motor Company, a firm of which he was co-founder in 1887 with premises at East Quay and later in Eastover, Bridgwater.

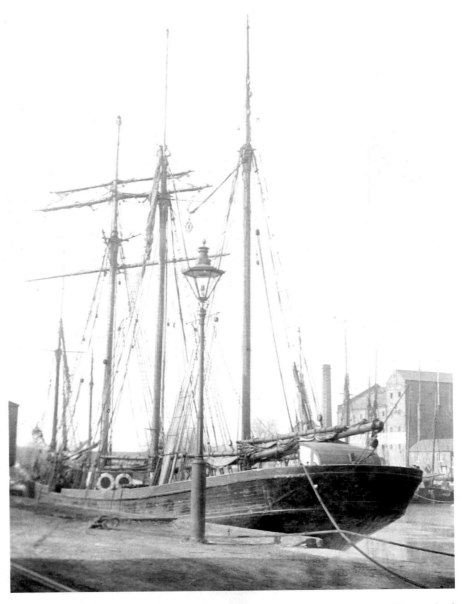

Registered at Bridgwater in 1903 but built at Milford in 1874, the 76-ton *Ermenilda* was the first locally registered ship to fall victim to German enemy action when she was sunk on 4 August 1916 by a bomb in the English Channel. At the time she was owned and captained by H. Hamblin of Gordon Terrace, Bridgwater, and was carrying a cargo of stone. A German submarine ordered the ship to be cleared within five minutes, the crew of four, including Mr Bailey and Mr Perks of Bridgwater, taking to a small boat which was cast adrift. A bomb placed on the forecastle was detonated by a time-fuse and the *Ermenilda* sank within ten minutes. After two hours of aimless drifting, the crew were picked up by a Russian steamer 25 miles off Portland and taken to Weymouth. This picture shows the *Ermenilda* alongside Ware's Warehouse at Bridgwater docks with the British Oil and Cake Mills (later Bowerings) in the background .

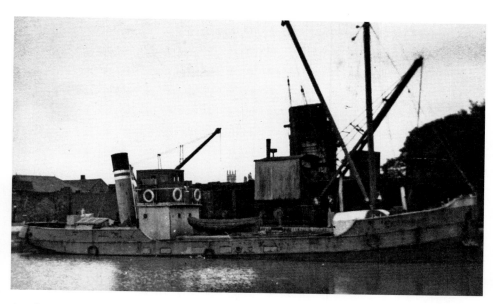

Another steamship owned by Sully & Co., the *Borderdene*, is seen here unloading coal brought from South Wales to the firm's wharf in Bridgwater docks in 1939. Built at Namur in 1913, this 122-ton vessel was mined in January 1942.

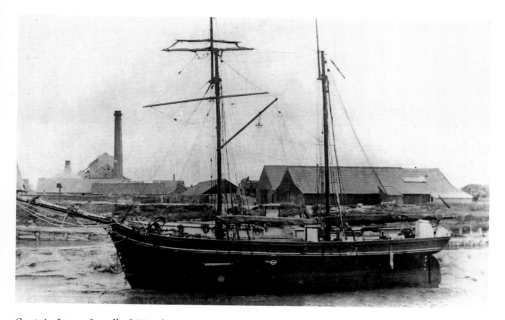

Captain James Lovell of Watchet was the master of the *Charles*, a schooner built in Bridgwater in 1857. On 18 December 1917 Captain Lovell was taken prisoner when this vessel was sunk by a German submarine in the English Channel, his mate being killed and two of his crew captured. This photograph of the ill-fated *Charles* was taken alongside the Bristol Road wharf, acquired in 1922 by John Board & Company. This firm had been established in 1844 and had other premises at Dunball and Dunwear.

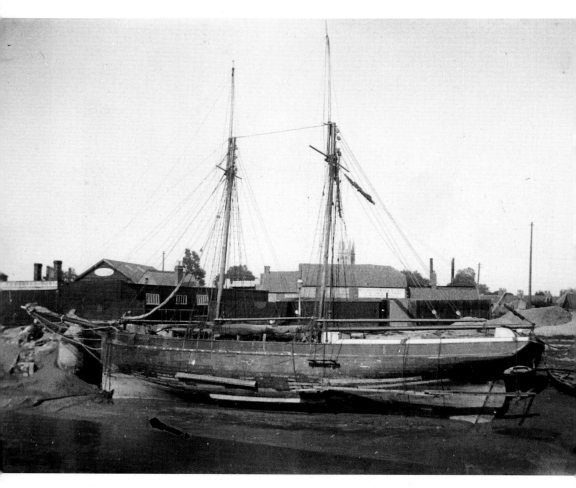

Low tide allows the employees of Carver & Son to caulk the hull of this 1884 schooner, *Kings Oak*. Caulking was the packing of the joints and the stopping-up of gaps between the planks of the hull with hemp strands driven into the seams with irons and mallets. Sometimes the fibre was impregnated with tar or pitch and applied to the seams. Planks suspended by ropes along the side of the hull allowed the caulkers to work on the seams. The *Kings Oak* sank at Swansea in 1923 after failing to rise on the tide while sheltering from heavy weather on a journey from Liverpool to Bridgwater with a cargo of coal. Sadly, seaman Robert Snell of Mount Street, Bridgwater, was drowned. The vessel was refloated and repaired, and continued to trade before being broken up at Appledore, North Devon, later in the same year.

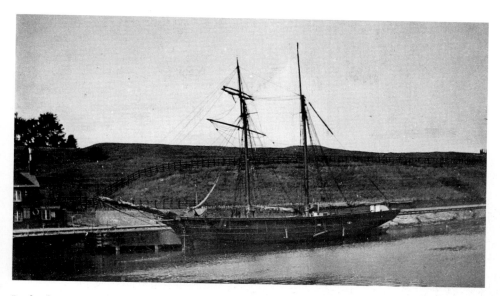

In the foreground of this photograph is the *RKP*, a 67-ton schooner built at Feock, Cornwall, in 1870 and registered at Bridgwater in 1890. Partly owned by Edward Hamblin of Bridgwater and captained by his brother Charles Hamblin, this graceful-looking vessel went down with a 120-ton cargo of loose fish-curing salt en route from Gloucester to Bantry, Ireland, on 29 October 1910.

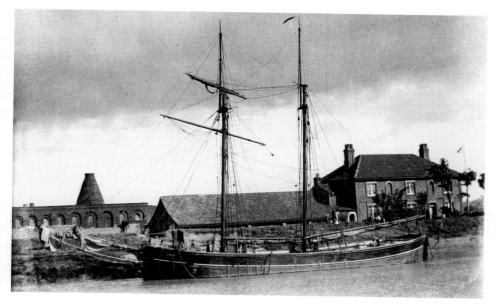

The two-masted single-topsail schooner *Lilla*, loaded with bricks and tiles alongside the brickyard of Colthurst Symons. With high tide imminent, her fore canvas topsail would be set on the upper yard and her journey downriver would begin. Built in 1868 at Freckleton, she was registered at Bridgwater in 1894 and hulked in 1928.

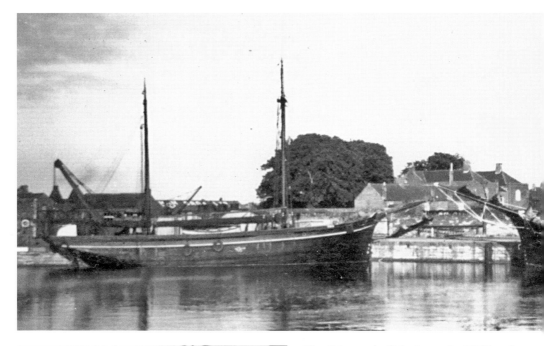

The *Trio* was built in Jersey in 1877 and originally named *Warinula*, later changed to *Margherita*. Built as a schooner and later re-rigged as a ketch, her mizzen mast was fashioned from the timber of her old mainmast. Prior to her ownership in 1895 by the Escotts of Watchet, she was used in the Newfoundland cod trade. She is pictured here at Bridgwater docks while in the ownership of Captain Joseph Warren of Bridgwater, but after 1927, when an auxillary motor was fitted. She capsized in the Parrett in March 1939.

On the left is the ketch *Sunshine*, built by Charles Burt of Falmouth in 1900 but owned by Captain Lewis Nurse of Bridgwater. Under her bowsprit she carried the beautiful figurehead of a full-length figure of a woman in a broad-brimmed hat, shown here in close-up. In early December 1937, in high seas while bound for Dublin from Bridgwater, this 99-ton vessel grounded heavily near the eastern breakwater of Fishguard, and after sending out distress signals three crew members were rescued by the local lifeboat.

EIGHT

THE UPPER REACHES

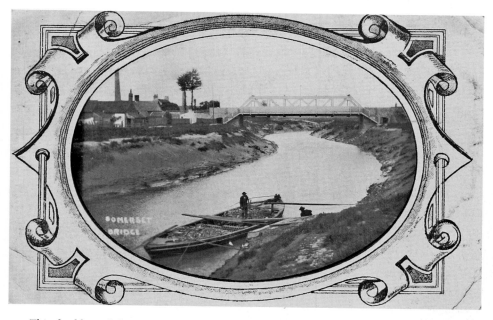

This double-ended Parrett barge loaded with bricks and tiles is shown alongside the
Somerset Bridge works, where the cargo would be taken into Bridgwater and transferred
to a sea-going ketch for onward transmission to all corners of the British Empire. With
the advent of railways between the towns, there was a rapid decline of exports both from
Bridgwater docks and the Parrett wharves which had been used for centuries. By failing to
take account of new technology, alternative building products and means of manufacture,
the brickyards let the clay industry of the area fade and then fail.

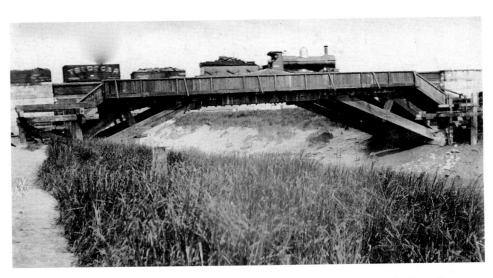

In the hamlet of Somerset Bridge a river crossing for the Bristol & Exeter Railway Company was constructed by the young, but already celebrated, engineer Isambard Kingdom Brunel. He started work on the bridge in 1839. A centering constructed to support the arch was not removed until 1843, but there was a shift in the foundations and Brunel was required to design a replacement span. It is this replacement span, constructed of laminated timbers, that is shown here. By 1904 a new bridge of steel girders was in place and remains to this day.

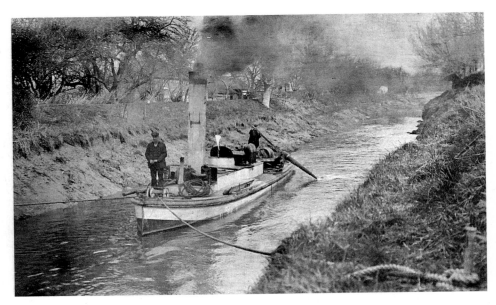

Designed and built by W. & F. Wills Ltd of Bridgwater for the Somerset Drainage Commissioners in 1894, this hydraulic eroder named *Pioneer* used its high-pressure water hoses to clear accumulated silt from the bed of the river and banks. This picture appears to have been taken upstream from Burrowbridge in about 1905.

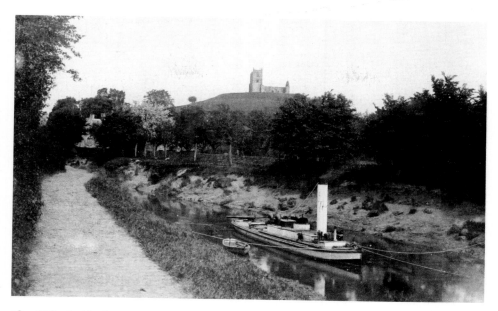

The 62ft steel-built steam scourer *Eroder*, designed by Frank Wills of Bridgwater, used a Leval 110hp turbine which powered centrifugal pumps to clear the build-up of mud and silt along the Parrett banks. The pumps used 1,400 gallons of water per minute at 70lb psi and required three men to operate the vessel.

The great freeze of February 1895 brought distress and disaster to many local families. Soup kitchens were set up as well as a distress relief fund, so that local residents could obtain food supplies. However, in the midst of such winter hardship there was some light relief, when, for example, tea parties were held, and fried pancakes were cooked over a brazier on the solid ice of the Parrett, in this instance at Moorland (Northmoor Green).

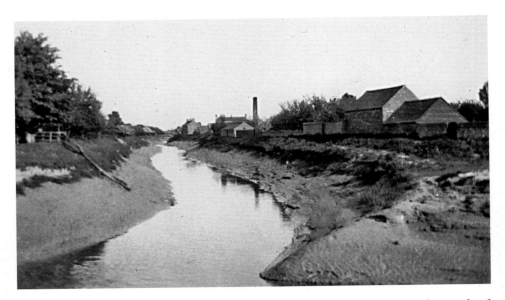

The confluence of the River Tone and River Parrett, some 200 yards to the south of Burrowbridge. The Tone joins at right angles from a south-westerly direction.

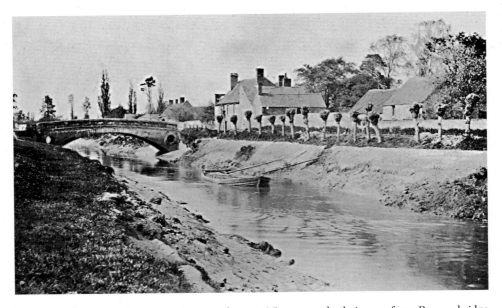

During the seventeenth century barges of up to 15 tons made their way from Burrowbridge to Ham Mills, some 3 miles from Taunton, carrying coal and other goods. By the early part of the nineteenth century over 14,000 tons of cargo were brought into Taunton on the Parrett and Tone each year. In 1827 the opening of the Huntworth to Taunton Canal led to fierce competition between the Tone Conservators and the management committee of the canal company, an agreement not being reached until 1832. Two further canals linked in with Taunton: the Chard to Creech St Michael Canal, which opened in 1842, and the Grand Western Canal from Tiverton to Firepool, Taunton, opened in 1838.

r hundreds of years the drainage of the Somerset levels has been vital for agricultural and social
asons, and as far back as the thirteenth century the monks constructed ditches and banks to protect
e levels from flooding. Between 1770 and 1825 extensive attempts were made to drain the levels,
cluding the construction of the King's Sedgemoor Drain and its associated ditches and rhines. By 1830
merset had introduced its first steam pumping station at Westonzoyland, capable of lifting water from
e levels, and discharging it into the River Parrett. The original beam engine proved inadequate, and
1861 a more successful centrifugal pump by Easton & Amos was placed in position, remaining in use
til 1951. Now of historical significance and preserved by enthusiasts, this engine is fired regularly and
n be viewed by the public on certain open days.

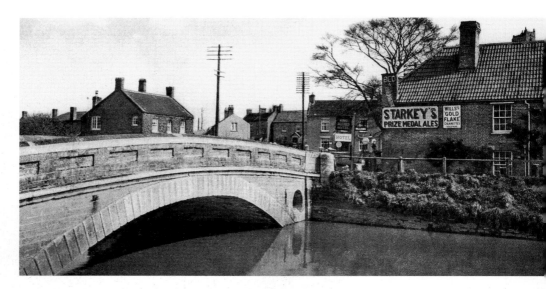

The A361 Taunton to Street road crosses the River Parrett at Burrowbridge at a point overlooked by Burrow Mump, which is surmounted by St Michael's Chapel. The bridge, with its granite arch and parapet, was built in 1825 from blue lias blocks, the round aperture on each side of the arch allowing floodwater to drain away. The King Alfred public house and restaurant on the right of the photograph remains, as well known and well used today as back then.

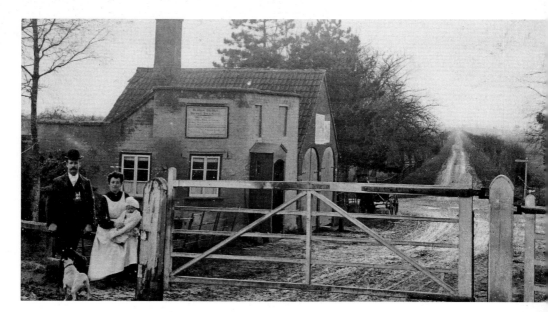

The toll-gate and toll-house on the river bridge at Burrowbridge viewed from the Othery side. In the picture, the tollkeeper, his wife, child and small dog pose proudly for the photographer. The signboard on the side of their home sets out all the relevant tolls. The right to use public roads free of toll having once been a strong political issue, it is interesting that all these years later, tolls are again being introduced on newly constructed roads.

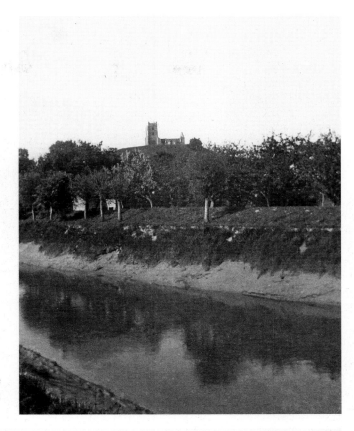

he River Parrett is well known
r its elvers, Burrowbridge and
nball being two of the favourite
ations for fishermen. The locally
ade net was designed on an 18in
me covered with fine mesh, held
place by two bent withies crossing
m each corner. The elvers, usually
ught at night during February
d March, are transparent, some
to 3in long and the diameter of a
atchstick. They are scooped out of
e river and packed in boxes and
nt to local hotels and restaurants
well as to London and other
stronomic centres. In recent years,
ensed elver fishing on the Parrett
s become very popular as the price
elvers has increased, but poaching
not unknown!

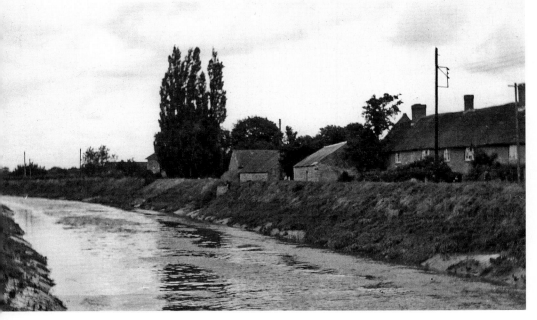

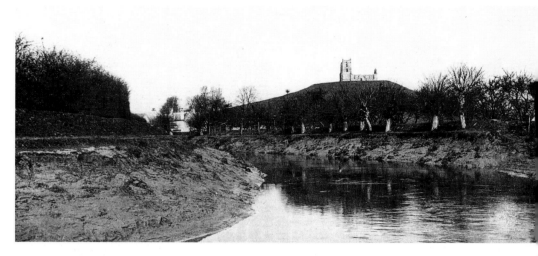

During the nineteenth century the upper reaches were easily navigable. Horse-drawn barges took t
coal, brought into Bridgwater by ketch from Bristol and South Wales, upriver towards Langport, t
wharves and tributaries constituting what became known as the upper reaches. On the outgoing ti
goods were taken back to Bridgwater for transfer to seagoing vessels. Not only could the barge hors
jump fences while towing, they could also jump on to the deck of the barge when it was necessary
pole to the opposite river bank. The last barge to Burrowbridge was logged in 1928 and the last barge
far as Langport in 1910, although barges carrying withies passed through in the 1940s.

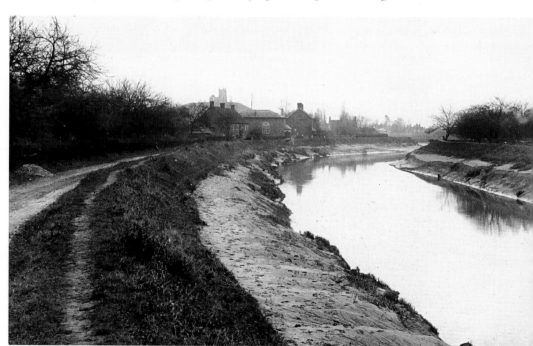

In 1821 an Act of Parliament created a body of commissioners empowered to demolish the old bridge and construct a new one, for which £2,500 had to be raised by the issue of £50 bonds bought by local residents. Construction took place in 1825 and in 1828 tolls raised £146, but then the railways took over and by 1883 income from tolls had dropped to £41. The introduction and popularity of the motor vehicle led to a resurgence of road use, and by 1921 the toll income had risen to £252 and £513 by 1925, all from the 3d payable to the gatekeeper. Burrowbridge was the last toll-bridge in Somerset and was not 'freed' until 1946. This comic postcard was published in about 1912, and makes wry fun of the section of the original Act of Parliament which stated 'for every horse, mule or ass drawing, 3d'.

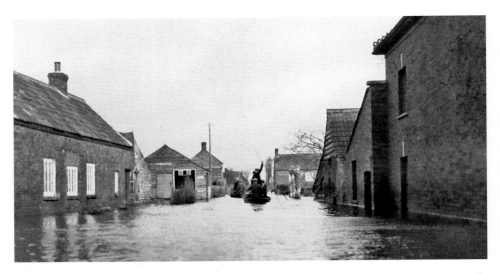

At 3.00 a.m. on Saturday 7 December 1929, following unprecedented rainfall and high winds throughout the preceding fortnight, the River Tone burst its banks at Athelney. The breach occurred on the property of Mrs Miller at Stanmoor, where the embankment separated the Tone from the low-lying lands of Stanmoor, King's Sedgemoor, West Sedgemoor, Aller Moor and the moors above Langport. The villages of Athelney, Stathe, Stoke St Gregory and Burrowbridge were devastated and the withy beds badly damaged, as were hayricks, farming implements, property and furniture. Poultry and livestock were lost, but, fortunately, there was no loss of human life. A county relief fund was started to relieve the hardship and distress to the community, as insurance failed to cover loss by 'Act of God'. It took many weeks for the water to recede and even longer for life in the community to return to normal. Indeed, some said that the floods marked the turning point between the 'old days' and what followed, as new ideas and practices were introduced to prevent another disaster on the same scale, not all of which found favour.

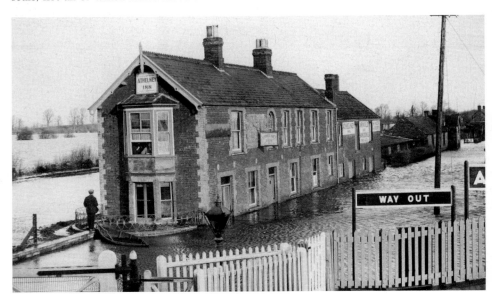

NINE

LANGPORT

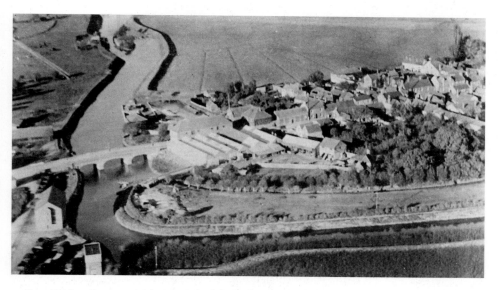

Bow Bridge, Langport, photographed from the air in about 1933 with the lock-house, offices and floodgate in the top left-hand corner. This three-arched bridge was built of Pilsbury stone in 1839 at a cost of £3,989. It replaced a nine-arched bridge, each arch of which had been so narrow, only barges up to 7 tons could pass through; indeed, in 1800 a tramway had been built to hoist barges up to 20 tons over the old bridge. The centre arch of the new bridge, larger than those on either side, allowed bigger barges easy passage. Messrs Stuckey and Bagehot formed the Parrett Navigation Company, and at a cost of £38,000 constructed a canal to Westport with a series of locks that enabled the large 20-ton barges to get even further inland. By the 1850s almost 170,000 tons of cargo a year was passing through Langport. However, the advent of the railways and the introduction of bulk transportation resulted in river-borne cargo diminishing.

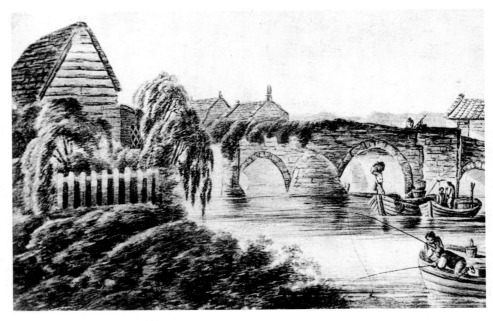

An early sketch of the nine-arch stone bridge across the River Parrett at Langport. At this time only cargo up to 7 tons could pass through the narrow arches.

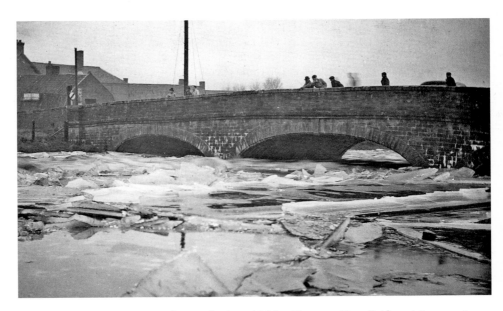

An icy view of Langport Bridge in the late 1930s. The new Bow Bridge at Langport was built with jutting keystones in 1839 to replace the old bridge. Although the central and larger of the three arches then enabled cargo up to 20 tons to pass through, the absence of a towpath under the bridge required the horses to be unhitched on one side, and reattached on the other.

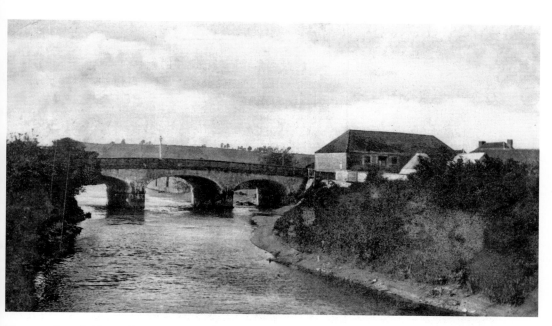

The new Bow Bridge at Langport opened up the prospect of moving cargo as far as Ilminster. The local families of Stuckey and Bagehot, having formed the Parrett Navigation Company, proceeded to cut the canal from Midelney to Westport, thus linking the Parrett with the River Isle, from where a short journey by road took the cargo right into Ilminster and on to Chard. The families of Stuckey and Bagehot had been well-known partners in the multiple-share ownership of trading vessels as far back as 1707. Trading between local ports and South Wales in garden produce, bricks and tiles together with other items from local industry, they brought coal and factory goods as well as passengers into Somerset. By the late 1820s they had shares in much larger sailing ships, usually 400-ton barques plying overseas and trading in Canada and the East Indies. The canal opened in 1841, and by the 1850s over 170,000 tons of cargo was passing through Langport. However, the opening of the rail link to Taunton, Langport and Yeovil in 1853 resulted in a gradual decline in the use of the canal and by 1910 only one barge was operating on the River Parrett between Langport and Bridgwater.

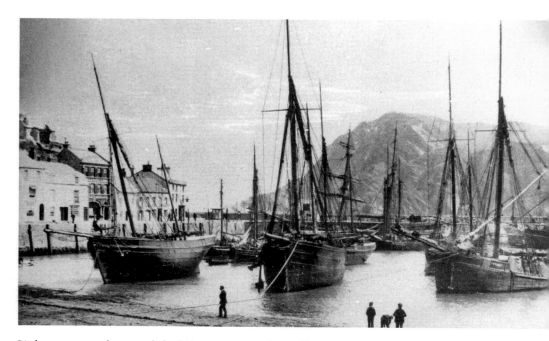

Little appears to be recorded of Langport as a shipbuilding town, but it has the distinction of having constructed at least one vessel, listed in Lloyds Register as the trow *Thorney*, in 1847. While it seems improbable that a 65-ton trow could have floated in the upper Parrett, unless the 'stream' was deeper in those days, records show that this open-hold vessel with canvas side-cloths, typical of these undecked trows, was indeed launched. The *Thorney* was skippered in the 1880s by George Trunks of Williton and later by Captain Johnson. Registered at Bridgwater in 1849 and owned by Messrs Sully & Co., she ran aground in 1890 but was refloated. However, her luck ran out on Saturday 23 August 1902, when laden with coal, she was involved in a collision with the ketch *New Design* near Bridgwater docks. The bill of her own anchor pierced her bow and she sank rapidly. At low tide two bargeloads of coal were removed from her hold, her leak was stopped and she was floated to the outer basin of the docks, but in such a dilapidated condition that she had to be hulked. The *Thorney* is pictured on the extreme right of this photograph taken at Ilfracombe in about 1890.

BIBLIOGRAPHY

Anderson, J., *Coastwise Sail*, Percival Marshall, 1948.
Bouguet, M., *West Country Sail; Merchant Shipping, 1840–1960*, David & Charles, 1971.
Bridgwater Mercury, 1870–1970.
Eglinton, E., *The Last of the Sailing Coasters*, HMSO, 1982.
Farr, G., *Somerset Harbours*, Christopher Johnson, 1954.
——., *West Country Passenger Steamers*, T. Stephenson, 1967.
——., *Ships and Harbours of Exmoor*, Microstudies, 1970.
——., *Wreck and Rescue in the Bristol Channel*, Vol. 1, D. Bradford Barton, 1966.
——., papers for Somerset Maritime History, Somerset Record Office, 1979.
Fitzhugh, R. & Loudon, W., *Bygone Bridgwater and the Villages*, Avalon Press, Coventry, 1987.
——., *More Bygone Bridgwater and the Villages*, Avalon Press, Coventry, 1989.
Greenhill, B., *The Merchant Schooners*, Conway Maritime Press, 1988.
Harrison, J.D., *The Bridgwater Railway*, Oakwood Press, 1990.
Mote, G., *The Westcountrymen*, Badger Books, 1986.
Murless, B.J., 'The Bath Brick Industry of Bridgwater', *Journal of the Somerset Industrial Archaeological Society*, No. 1 (1975) 18–28.
——., *Bridgwater Docks and the River Parrett*, Somerset County Library, 1983.
Norman, B., *Tales of Watchet Harbour*, self-published, 1985.
Porter, E., Bridgwater Industries Past and Present, self-published, 1971.
Shaw, A., 'The Bridgwater Flatner', *Mariner's Mirror*, Vol. 55 (1969), 411–15.
Slade, W.J., *Out of Appledore*, Conway Maritime, 1972.
——. & Greenhill, B., *West Country Coasting Ketches*, Conway Maritime, 1974.

AUTHOR'S NOTE

Over seventeen years have elapsed since *Bridgwater & the River Parrett in Old Photographs* was first published and it has long since been out of print. During the intervening years I moved from Coventry to Taunton and I have continued collecting photographic scenes of the river and docks. When so many people asked me for copies of the original book, I decided it was time to update it with a few new photographs. It took longer than I anticipated because some of the language and phraseology used before seemed dated, and quite a few things have changed with time, so what I set out merely to copy became a total rewrite!

However, the digital age has enabled some of the photographs to be enhanced, and with the prospect of the river taking on a new life, I hope that readers will enjoy this update as much as the original, but the pictorial memories of the past which I have tried to recapture have only been possible because of the help and support of others. Those whom I acknowledged previously, I thank again, and I am indebted to my wife Celia, without whose computer skills, advice and support, this book never would have reached the publishers.

Every effort has been made to ensure the accuracy of the facts contained in this book, but memories fade, recollections falter, and records may be misread. I apologise for any accidental or unintentional mistakes, and would welcome any corrections, further information, other photographs, and personal family stories and anecdotes. I can be contacted via the publishers, The History Press.

Whether any of the vessels pictured still exist, I cannot guarantee. Research suggests that two or three were 'to be restored' including the *Bertha* which features on the website of the World of Boats, Eyemouth, Berwickshire. Thankfully, the famous *Irene* and the *Kathleen & May* have been rescued and restored, but for all of the others, photographs may be the only evidence of their existence and the heritage of shipping along the River Parrett as well as the docks along its course. Shipping brought fame and fortune to the area by trade and employment, an affluence that deteriorated as the ships disappeared. Regeneration has occurred and continues by other means as needs have changed, and the river will flow, come what may! Therefore, it is in optimism for the future, rather than sadness for the loss of those handsome vessels that this book has been published, in the hope that it gives pleasure to those who enjoy recollecting the nostalgic past of sail and steam, ship and shipmaster, pill and port, coast and river.

Rod Fitzhugh, May 2011